GIFTS AND DISCOVERIES

THE MUSEUM OF ARCHAEOLOGY & ANTHROPOLOGY, CAMBRIDGE

Edited by Mark Elliott and Nicholas Thomas

SCALA

First published in 2011 by
Scala Publishers Ltd
Northburgh House
10 Northburgh Street
London EC1V OAT
www.scalapublishers.com

In association with the Museum of Archaeology
and Anthropology, Cambridge
www.maa.cam.ac.uk

ISBN: 978 1 85759 715 8

Editor: Sandra Pisano
Designer: Nigel Soper
Printed in China

10 9 8 7 6 5 4 3 2 1

Acknowledgements
The following members of Museum
staff researched, drafted or wrote
sections of the text: Robin Boast, Lucie
Carreau, Christopher Chippindale,
Jocelyne Dudding, Sudeshna Guha,
Imogen Gunn, Rachel Hand, Sarah-Jane
Harknett, Mary Hill Harris and Anita
Herle. The editors also warmly thank
Liana Chua, Annie Coombes, Preston
Miracle, Kate Spence and Mark Turin for
information and assistance. Gwil Owen
and Jocelyne Dudding took the
photographs.

The book could not have been published
without the financial help of the Friends
of the Museum of Archaeology and
Anthropology. Special thanks to Peter
Chapman, Carol Bell and Rachel Smith
for their generous support.

FRONT COVER:
**Carving of two human figures
and an animal** (see p.50)

FRONT COVER FLAP:
Border of a shawl (see p.64)

BACK COVER:
Jade mask
Height 14 cm
Olmec (1500–400 BC) Mexico
Donated by Louis C.G. Clarke
1962.7

BACK COVER FLAP:
Bronze *ge* ceremonial axe head
(see p.37)

CONTENTS

INTRODUCTION
by Nicholas Thomas

THE MUSEUM OF ARCHAEOLOGY AND ANTHROPOLOGY (MAA) at the University of Cambridge holds world-class collections of indigenous art and artefacts from throughout the world. The archaeological discoveries range from early hominid tools through later Stone-Age materials to Roman and Anglo-Saxon finds from Britain. Relative to the great London museums and to bigger city museums elsewhere in Britain, MAA is small – just four main galleries are spread over three floors of an evocative early twentieth-century building. But this relative compactness belies the range and importance of the Museum's holdings.

The collections consist of some 800,000 artefacts, nearly 200,000 historic photographs and an archive of letters, fieldworkers' research notes and associated documents. Of this vast quantity of material, only a small sample can be exhibited at any one time, though reserve collections are frequently accessed by students and researchers, including visitors from communities represented by the collections.

This great assemblage is eclectic; and Cambridge came by its wealth of objects in a bewildering variety of ways, some of which are traced in this book. They include many artefacts representing the cultures of peoples who have since suffered great upheavals and losses. They include pieces of unique historical significance – the very first Aboriginal objects collected from Australia by any European, for example. Collections of this kind reached the Museum through networks linking explorers, travellers, colonial officials and Cambridge scholars and scientists. The sheer reach of these relationships – in the context of European expansion in general and the British Empire specifically – brought, over time, an extraordinary range of exceptional art works and artefacts to the Museum. Given the unequal, indeed exploitative dimension of the imperial world, it comes as something of a surprise that a good many of these wonderful artefacts were given as gifts from the peoples who made or used them, or they were bought or bartered on terms they considered fair. Yet certain collections were acquired under more controversial circumstances and bear the legacy of empire's darker side. Either way, these artefacts exemplify not only the cultures that created them, but moments in history, when, for better or worse, objects were acquired by Europeans on their travels, eventually to reach the Museum. Those travels reflect the beginnings and the formation of the global society we all now inhabit.

This book gives a taste of the variety and interest of the collection through a very small, though broadly representative sample of objects. Works have been selected for their intrinsic interest and for what they reveal of the Museum's history. The book recounts some of the stories behind these objects, and how they came to be assembled from all over the world with the intention – the founding curators hoped – of informing and stimulating students of what were then the new disciplines of anthropology and archaeology. The collections continue to be vital teaching and research resources, and now stimulate interest from broader public audiences as well as scholars and students. But the ways in which we perceive these collections today and the questions we ask of them have changed profoundly. They remain important to the disciplines of archaeology and anthropology – which have been reinvented several times over since the Museum was founded – but they are also significant for many people, including artists, historians and, not least, the indigenous peoples whose ancestors created and used the objects.

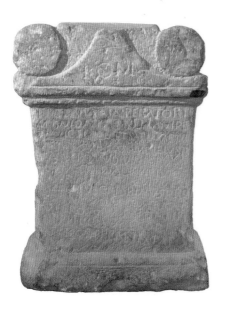

▼ **Foundation stone erected by the First Cohort of the Vangiones**
Roman (43–410 AD)
Risingham, Northumberland

Deposited by the Master and Fellows of Trinity College
Ex Cotton Collection D 1970.7

Archaeology and anthropology only emerged as formally taught fields and professional disciplines at the end of the nineteenth century; and it was only during the first quarter of the twentieth century that they were officially established as subjects in which students could study for a degree. In another sense, of course, they had been around for centuries. Seventeenth- and eighteenth-century students of natural history had long argued about physical differences among humans, the unity of the species, the impact of environment upon the temperaments and customs of particular peoples, and the emergence of legal and political institutions. In the late eighteenth century, these debates were given particular impetus by new observations of native peoples – by participants in Captain Cook's voyages, for example – and by the interest in the 'noble savage' among philosophers such as Rousseau. Similarly, gentlemen and scholars had long been interested in monuments, local antiquities and relics, which they drew, wrote about or assembled in private 'cabinets of curiosities' and early museums. On a larger scale, the Ashmolean in Oxford was established in 1683 and the British Museum in 1753. Both initially incorporated diverse natural specimens

and artefacts, including ancient archaeological objects as well as pieces from recently encountered exotic peoples such as native Americans and Pacific Islanders.

The Museum of Archaeology and Anthropology was established later, in 1884, but older collections already existed in Cambridge, which in due course were transferred to the Museum. Trinity College's famous Wren Library held, until the end of the nineteenth century, a display of curiosities that came together in much the same way as the founding collections of the older London and Oxford museums. The College held 15 stones, bearing Roman inscriptions, that had belonged to the prominent antiquarian Sir Robert Cotton (1571–1613). He was a friend of William Camden, whose 1586 book, *Britannia*, had been of tremendous importance in advancing interest in the sites and antiquities of Roman Britain. Some of the stones were obtained during a tour through England's northern counties that the two men undertook in 1599. The Trinity collection also included some 120 artefacts gathered during Captain James Cook's first voyage to the Pacific. In many cases, these were the first artefacts obtained from the indigenous peoples of the various islands and coasts visited. Hence, while Cotton's collection reflected the inauguration of serious inquiry into Roman Britain, the Cook collection marked the beginnings of European interest in the arts and peoples of the Pacific.

It was not, however, the accumulation of collections in the colleges that eventually gave rise to a museum. The campaign to establish an institution was driven by members of the Cambridge Antiquarian Society, which had been established in 1840. The CAS was one of many local historical, architectural or archaeological societies created in the period. Some groups were dedicated mainly to publishing early archival records, some to ecclesiastical history, others to ruins and finds of antiquarian interest. In the case of the CAS, the members – nearly all University men – held meetings, read papers and published reports, often on aspects of local history. They also presented gifts of books and specimens, which began to accumulate and eventually led to concerns about finding space for the growing collection. The Society had its ups and downs, but as a result of the efforts of a particularly dynamic Secretary, membership grew dramatically in the 1870s and 1880s, and it was over this period that, finally, the University was successfully lobbied to establish a museum for the Society's collections.

In fact, there was a triple impetus for the creation of a new institution. The CAS campaign converged with the interest of Cambridge's largest museum,

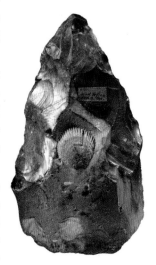

▲ **Hand axe knapped around fossil shell**
Length 13.2 cm
Palaeolithic (about 400,000 years ago). Elveden, Suffolk

Donated by the Cambridge Antiquarian Society
1916.82/Record 2

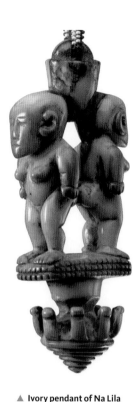

the Fitzwilliam, which sought space for a teaching collection of casts of classical sculpture. And at the same time, Sir Arthur Hamilton Gordon sought to present to the University a collection he had amassed as Governor of Fiji from 1875 to 1880. Gordon was a Trinity man, the son of a Prime Minister and a former President of the Cambridge Union, who had been governor of several other colonies before Fiji. One of his private secretaries, Alfred P. Maudslay, later a pioneer of Central American archaeology, also wished to donate a considerable number of Fijian artefacts. In addition to these collections, the name of a prospective curator was also pressed upon the University. Baron Anatole von Hügel, of English and aristocratic Austrian parentage, had arrived in Fiji just before Gordon and Maudslay. He was young, enthusiastic and open-minded, and quickly became passionately interested in Fijian culture, building good relations with the Fijians and collecting avidly.

The Museum's founding collections thus drew together 851 objects from the Cambridge Antiquarian Society and over 1,500 Fijian artefacts, some 500 from Gordon and Maudslay and over 1,000 from von Hügel himself. The Fijian holdings importantly came to include large numbers of photographs and documents that have been vital to more recent work on these collections. Most of the CAS objects were from Cambridgeshire itself – the collection included particularly fine Iron-Age pieces – but a few were from elsewhere in England. Some prehistoric worked flints were from Denmark, probably reflecting the Society's links with the nineteenth-century Danish scholars who played a key role in promoting the study of prehistoric archaeology. From the start, the collections were wide-ranging – from finds in and around Cambridge to the Antipodes, from pieces thousands of years old to objects that were relatively new, reflecting confrontations between indigenous cultures and European colonisation. This mix of objects foreshadowed sustained archaeological investigations in and around Cambridge and elsewhere in Britain, and field expeditions, both archaeological and anthropological, that ventured right around the inhabited world.

Von Hügel's appointment would prove fortuitous. Dedicated, charming and persuasive, he worked enormously hard to build the collections and won friends for the new institution, among them Sir James Frazer, author of *The Golden Bough,* the famous early study of magic and religion; and A. A. Bevan, the wealthy Professor of Arabic, who funded many purchases. Von Hügel corresponded extensively with travellers and others with ethnological interests, encouraging them to put together collections for Cambridge, and within England he bought pieces and collections from dealers and auc-

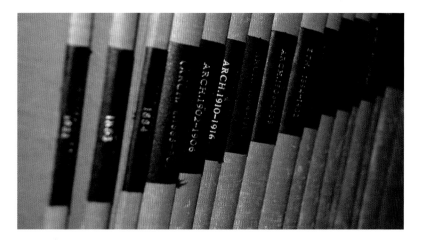

◀ **Registers of accessions into the Museum's collections, dating from 1883 onwards**
MAA Archives

tions, very often with his own money. Important collections were made by field researchers who were not anthropologists, and by University men from quite different disciplines. J. W. L. Glaisher, a Trinity mathematician, was for example enthusiastically interested in the art of the American Northwest coast; it was he who commissioned an agent to acquire the Haida totem pole (see pages 76–77) and many other significant pieces from the region.

The Cambridge Antiquarian Society continued to be lively (and continues to be, today). Its public lectures – by figures such as the Egyptologist Flinders Petrie – sometimes drew audiences of 300–500 people. Though there was virtually no funding for Museum staff or acquisitions, CAS members, along with others, presented finds and purchases, and volunteers assisted with day-to-day work.

▼ **Mask from a mortuary ritual**
Height 56 cm
Late 19th century
New Ireland, Papua
New Guinea
Donated by Professor
Henry Sidgwick
E 1890.179

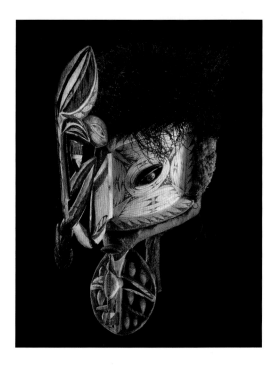

Initially, the Museum was not linked to any particular department or faculty. Though a Disney Professorship in Archaeology had been established in 1851, the position was held by classicists, and until the late 1920s affiliated with the Faculty of Classics. A few scholars, however, were excited by the emerging field of prehistoric archaeology and by the study of native peoples' customs, institutions and technologies. Alfred Cort Haddon trained in zoology and planned to follow up

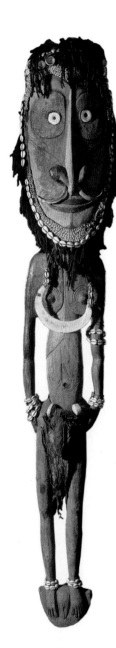

▲ **Initiation figure of a shamanic spirit (*Iamwail*)**
Height 175 cm
Iatmul; Amblamai, Sepik River, Papua New Guinea

Collected and donated by Ernest W. P. Chinnery *1930.101*

T. H. Huxley's studies in the Torres Strait, between the tip of Australia's Cape York and New Guinea. Over the course of his expedition of 1888–89, however, he became increasingly fascinated by the lives and customs of the islanders, and troubled by the impact of European commerce and Christianity upon them.

At this time, it was widely believed that many native peoples would die out with European expansion. Even the less pessimistic took it for granted that the distinctive traditions of indigenous groups would gradually pass away. These were misconceptions, however: although depopulation in some regions was indeed appalling, and though much customary knowledge was lost, local cultures and identities proved resilient. Yet the sense of urgency concerning the documentation of indigenous culture had positive results. Haddon, among others, turned to anthropology, moved to Cambridge and began lecturing and publishing – his *Decorative Arts of British New Guinea* (1895) was the first book published on any aspect of Oceanic art. And the genuine advance lay in the commitment to sustained work in the field. Haddon began to organise the 1898 Cambridge Anthropological Expedition to the Torres Strait, which would prove a landmark venture for the formation of anthropology as a discipline. His team of five included Charles Seligman, who went on to undertake, with his wife Brenda, important studies in the Sudan and elsewhere; and W. H. R. Rivers, a key figure in the development of kinship theory, experimental psychology and the treatment of shell-shock victims. (His fieldwork in the Solomon Islands with A. M. Hocart features in Pat Barker's celebrated 1995 novel, *The Ghost Road*.)

It is easily assumed that anthropological and archaeological collections created during the colonial age consist primarily of loot, indeed that most museum objects were stolen, illegally excavated or otherwise illegitimately acquired. The Cambridge collections, like those of all similar museums, include considerable numbers of artefacts acquired through dealers, or under circumstances which make it impossible to know their precise histories; whether or not these artefacts were obtained from communities or sites in ways we would consider ethically appropriate today cannot be known. But MAA's most important collections were generated through fieldwork by researchers who spent extended periods with communities and in many cases documented interactions and exchanges in considerable detail. Haddon was firmly opposed to looting, and censured researchers whom he knew had acquired objects without proper return. The anthropology and archaeology of the late nineteenth and early twentieth centuries inevitably

appears dated from our perspective today, but at this time many researchers – if not other travellers – collected more ethically than commonplace assumptions suggest.

On Haddon's return to Cambridge from the Torres Strait in 1899, he was appointed to a poorly remunerated lectureship that nevertheless gave anthropology formal status within the University for the first time. The support of the Disney Chair of Archaeology, William Ridgeway, along with various other professors, led in 1904 to the establishment of a Board of Anthropological Studies that embraced prehistory archaeology as well as biological anthropology. Hence, for the first time, a formal programme of teaching was set up.

The Museum had initially been established in a new building on land leased from Peterhouse, that still bears the inscription 'Museum of Archaeology' across its lintel. But von Hügel's vigorous efforts, and the major collections brought back from the Torres Strait, resulted in a great expansion of holdings by the end of the nineteenth century. It was clear that a larger building was needed. The University made space available on a substantial site purchased to house teaching departments and an architect, T. J. Jackson, was commissioned and his plans approved. Von Hügel worked hard to raise funds, and construction eventually began in 1910.

Internally, Jackson's design was inspired, rendering the Museum's upper galleries, in particular, enduringly evocative. Motivated possibly by the hope that a major totem pole might be acquired, the first and second floors were opened up by a magnificent light-filled atrium – which indeed did feature a spectacular totem pole from 1926 onwards. The space also incorporated the central section of Inigo Jones' 1638 choir screen from Winchester Cathedral. This had been removed in the 1870s but was rediscovered by Jackson, who also happened to be the architectural adviser to the Dean of the Cathedral. Jackson proceeded to work the disproportionately grand neoclassical arch into the end wall of the upper gallery. The combination of a sample of great church architecture, Haida monumental sculpture, and Oceanic and African art may have seemed bizarre, but in

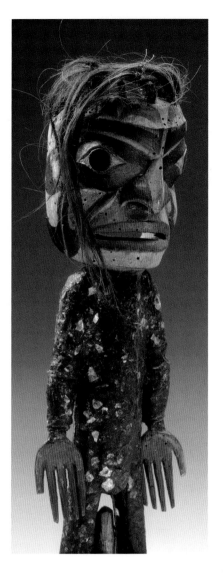

▲ **'Spirit helper' figure from shaman's headdress**
Height 36 cm
Tsimshian; Vancouver Island, British Colombia, Canada

Collected by Lieutenant-Commander Edmund Hope Verney between 1862 and 1865. Donated by Irene M. Beasley
Ex Beasley Collection Z 14856

truth was strangely appropriate. The interests of scientists and collectors were, at the time, eclectic; they might be stimulated as readily by British as by Egyptian, Indian or Papuan artefacts, and they did not in general have reservations about removing objects or edifices from their places of origin to draw them into a universal collection.

Anthropology continued to receive only limited institutional support in Cambridge, but in a wider sense was rapidly expanding. The Royal Anthropological Institute, MAA, the Pitt Rivers in Oxford and anthropological museums in the United States were engaged in lively international networks and the sharing of reports and theories through new journals. Haddon's students and associates were involved in important field projects in Melanesia, South Asia and Africa. Northcote W. Thomas, at one time a student of James Frazer, became the first government anthropologist in Nigeria and made important collections there, in the context of wide-ranging linguistic and ethnographic studies.

Von Hügel retired in 1921 and Haddon in 1926. For many years, Haddon had tried to shore up the shaky financing of Cambridge anthropology by stressing the importance of training in the subject for effective and humane

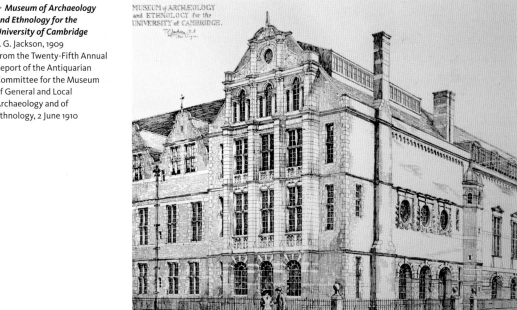

▶ *Museum of Archaeology and Ethnology for the University of Cambridge*
T. G. Jackson, 1909
From the Twenty-Fifth Annual Report of the Antiquarian Committee for the Museum of General and Local Archaeology and of Ethnology, 2 June 1910

colonial administration. Although he and von Hügel maintained productive contacts with many colonial officials – some of whom were genuinely curious about indigenous peoples and histories – the discipline never gained great influence on colonial policy, nor did much funding flow from the putative relationship. The strategy, in fact, had unfortunate results: when an endowment was found to establish the William Wyse Professorship, the first two incumbents, T. C. Hodsen and J. H. Hutton, were academically undistinguished products of the Indian Colonial Service. During the interwar decades, the dynamism of the subject shifted to the London School of Economics, where Bronislaw Malinowski presided over a brilliant new cohort of ethnographers. Cambridge continued to produce influential figures such as A. R. Radcliffe Brown, who established departments in Cape Town and Sydney before taking up a chair in Oxford; and Gregory Bateson, who married Margaret Mead, and became an influential early advocate of ecological thinking. But it was not until the Africanist Meyer Fortes replaced Hutton in 1951 that Cambridge again became a leading centre for anthropological research.

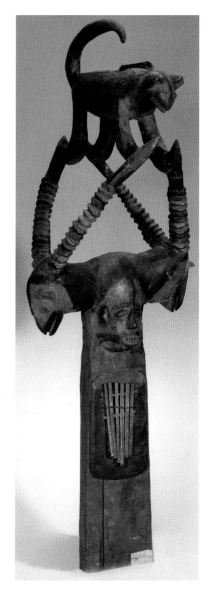

Cambridge archaeology was considerably more dynamic over the same decades. Grahame Clark was one of the first research students of the Faculty of Archaeology and Anthropology, which was formally established in 1927. He went on to campaign for the professionalisation of prehistoric archaeology, and for systematic scientific approaches to stone artefact typologies, mapping and environmental analysis. The Fenland Research Committee was established in 1932 to promote a cross-disciplinary study – informed by botany and geology, as well as archaeology – of the wetlands north of Cambridge. In the 1920s and 1930s, Dorothy Garrod, who came from a distinguished family of doctors and academics, and had studied at both Cambridge and Oxford, emerged as a major figure in Palaeolithic archaeology. In search of the origins of modern humans, she excavated important sites in Gibraltar, Kurdistan and the Levant, and was appointed to the Disney Professorship in 1939.

Von Hügel was succeeded as Curator of the Museum by Louis C. G. Clarke, a wealthy connoisseur and collector who later took up the directorship of the

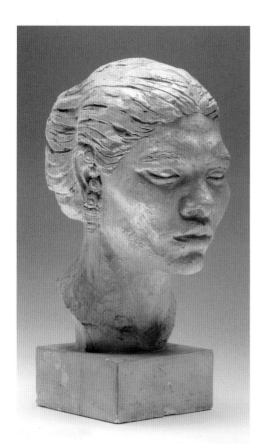

◀ **Sculpture with leopard straddling ram's horns, featuring a thumb piano (*ubo*)**
Height 109 cm
Early 20th century
North-central Igboland, Nigeria
Collected by Northcote Thomas
Z 14207

▼ **Portrait of Lepo, a woman of the Ho tribe**
Height 38 cm
Sculpture by Marguerite Milward, 1938
Jamshedpur, Jharkhand, India
Donated by the artist *1949.108*

Fitzwilliam Museum. Like von Hügel, he put great energy into expanding the collections and spent a lot of his own money acquiring both archaeological and anthropological pieces from dealers and auction rooms. Clarke had strong interests in the Americas and purchased major Plains Indian and Amazonian collections; early on he also acquired material from Widdicombe House, a stately home in Devon, which included a further group of artefacts from Captain Cook's voyages. In 1923, he participated in major excavations at Kechiba:wa in New Mexico and brought back important archaeological and ethnographic collections. Succeeding curators, Thomas Paterson and Geoffrey Bushnell, also both archaeologists, worked primarily in the Arctic and Central America respectively. Bushnell was succeeded in 1970 by Peter Gathercole, renowned for work in Pacific archaeology and on early voyage collections; the distinguished archaeologist of Africa, David Phillipson, was Director from 1981 to 2006. The Museum continued to play a significant role in Faculty teaching, hosted major research projects and began to place greater emphasis on temporary exhibitions, many of which not only arose from research projects but were experiments in themselves.

Much more could be said about the numerous field expeditions that Cambridge lecturers and curators have undertaken over the years, and the relationships that linked the Museum with anthropologists and archaeologists, and with local peoples, elsewhere in the world. These were relationships that produced not only collections but also knowledge – of the human past in particular regions, and of language, kinship, religion and politics. They also generated visual records – ranging from engaging sketches of people and places to photographic archives of thousands of images documenting the lives of societies in great detail. All of this knowledge depended upon collaboration – between local guides and workers, in the case of archaeological investigations, and between communities, elders, experts and artists with regards to ethnographic work. In many instances, the cultures represented through this work have suffered profound and

destructive change. Early fieldworkers' studies and collections provide, in many cases, vital records of languages and ways of life that have been transformed, and in some cases lost.

Over the past 20 years, research at the Museum has reactivated the connections that brought collections to Cambridge in the first place. Sustained conservation and documentary work on the photographic collections has opened up an extraordinarily rich visual resource that reveals much about past lives and encounters, as well as about specific artefacts. Projects with communities ranging from Torres Strait Islanders to the Sámi of northern Scandinavia and the Zuni of New Mexico have brought indigenous experts to the Musuem. What we know about artefacts and their social and cultural meanings has been enhanced dramatically by new dialogues, and also by the fieldwork now being conducted by students, curators and academics. These projects have taken images and information back to source communities, and in some cases important objects have been loaned to local or national museums in their countries of origin.

Our collaborations have often involved contemporary artists, some from indigenous communities, others interested in creating work that reflects upon the Museum and its history. The collections have thus come to incorporate not only great historic artefacts but new works that comment on culture and history and express the contemporary concerns of peoples who have suffered dispossession and ongoing marginalisation. Some feel that objects in European museums should be returned to their communities of origin. But others, such as Maori artist George Nuku, consider that these great works of art were gifts from his ancestors, which can now be seen as ambassadors for Maori culture in this country. The Museum has become a place in which these issues are energetically debated. The old stereotype of the museum implies a dusty cultural mortuary – in contrast, the art works and artefacts at MAA are very much alive. They are reinvigorated by new questions, they provoke argument and they stimulate all of us to think about the extraordinary range of past and present human experience.

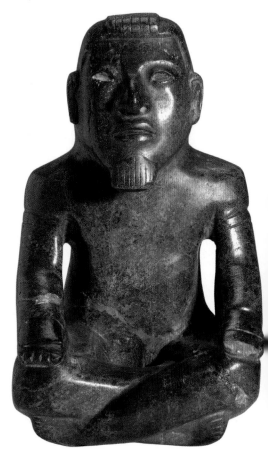

▲ **Jade figure**
Height 32 cm
Thought to be Mayan
(1–300 AD)
Gulf Coast, Mexico
Possibly purchased from
W. O. Oldman. Louis Clarke
bequest 1962.6

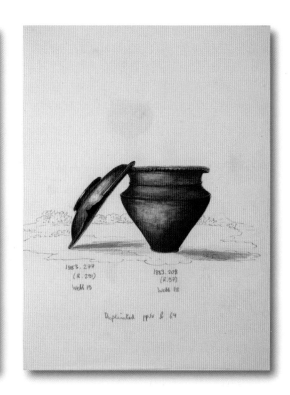

▲ **Public information poster**
Published by the Museum
of Archaeology and
Anthropology and the
Cambridge Antiquarian
Society, 1948–53

MAA Archives *Doc.307*

▲ **Watercolour of
Roman ceramics**
Watercolour by
J. M. Youngman, 1845–46
Great Chesterford, Essex

MAA Archives *GO2/3/2*

▶ **Clay brick inscribed with
the name of Nebuchadnezzar
II, King of Babylon, and an
unknown footprint**
Length 34 cm
605–562 BC
Babylon, Iraq

Ransom Collection 1923.1194 (Z 17406)

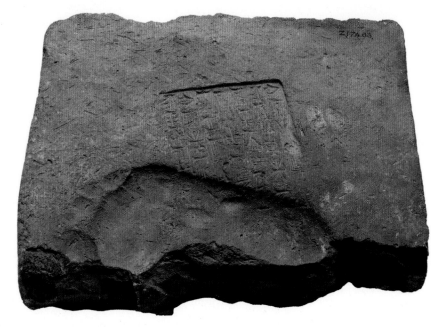

The oldest stone tools

THIS CHOPPING TOOL and early handaxe, discovered in Tanzania, represent humanity's first technologies. Though various animals use implements, they do so opportunistically. The hominid ancestors of modern people did something decisively different: they invented a tool type, with specific purposes in mind, which they went on to make and make again. The simplest early choppers were used to cut meat, break up bones and cut roots or bark. The handaxes that developed subsequently had aesthetic

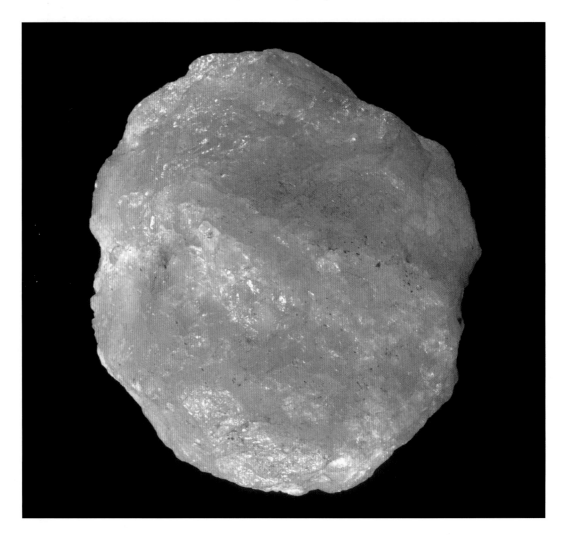

qualities that went beyond functional needs. The human interest in the artefact – the crafted object, both as a useful item and a bearer of some kind of style – was born.

These roughly shaped stones provide us, in the twenty-first century, with a direct link to humanity's beginnings. These artefacts also reflect a moment in the modern history of science – a revolution in the understanding of the human past.

Louis Leakey was born in Kenya of missionary parents, and studied in Cambridge in the 1920s. He went on to lead a series of expeditions to East Africa's Rift Valley, and in due course his first wife Frida, his second wife Mary and his sons Jonathan, Richard and Phillip, were all involved in major archaeological investigations in East Africa, notable for discoveries of fossil skeletal remains as well as finds of early stone implements.

In 1934, Leakey presented the Museum of Archaeology and Anthropology with a 'representative collection from the various levels' at Olduvai Gorge, Tanzania, consisting of worked pebbles, handaxes and other stone tools, including some of his first finds – artefacts up to two million years old.

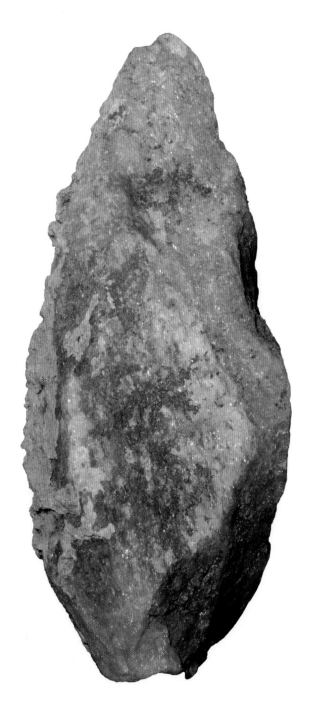

◀ **Stone chopping tool**
Length 8 cm
Lower Palaeolithic
(about 1,800,000 years old)
Olduvai Gorge, Tanzania

Collected and donated by
Louis Leakey, 1931
1934.1101 C

▶ **Handaxe**
Length 25 cm
Lower Palaeolithic
(about 1,650,000 years old)
Olduvai Gorge, Tanzania

Collected and donated by
Louis Leakey, 1931
1934.1106 C

Before the pharaohs

FOR MOST PEOPLE, ancient Egypt brings to mind the pyramids, sphinxes and pharaohs: the heritage of dynastic Egypt that remains so visible today. However, that civilisation was a phase within a much longer and deeper history. While less monumental, material from the Predynastic Period – beginning around 4000 BC and ending with the unification of Egypt around 3100 BC – gives important insight into the formation of the centralised and hierarchical state that defines Egypt in the imagining of the general public.

The Museum has an impressive collection from Hierakonpolis, known as Egypt's first city, as well as other important predynastic sites. Over this period, the inhabitants of Egypt first lived in settlements, then towns and cities. There was a shift, too, from simple graves to increasingly rich burials, though the treatment of the dead had not yet developed into the elaborate forms famously associated with the aristocratic interments of the Dynastic Period. The objects placed in earlier graves, such as items of jewellery, slate palettes and pots provide us with the main sources of information about this period.

These cosmetic palettes in the shape of fish are both beautiful and functional: they were everyday objects used by ordinary people to grind minerals for cosmetics such as kohl for eye make-up. Men and women used kohl to line their eyes in order to help protect themselves from the intense Egyptian sun – as well as to beautify themselves. Many palettes were made in the shape of fish, birds or other animals.

▶ **Slate cosmetic palettes**
Length 7 cm and 23.5 cm
Predynastic (4000–3100 BC)
Al Amrah and Hierakonpolis, Egypt
Excavated by D. R. Maciver and F. W. Green *1951.533 A, Z 45743*

▼ **A farmer threshing wheat in front of the pyramids**
Photograph possibly by Attaya Gaddis, 1907–37
Giza, Egypt
Hornell Collection P.66608.HNL

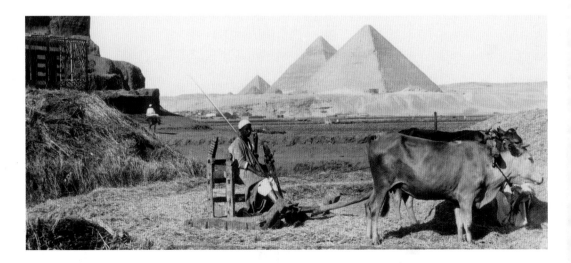

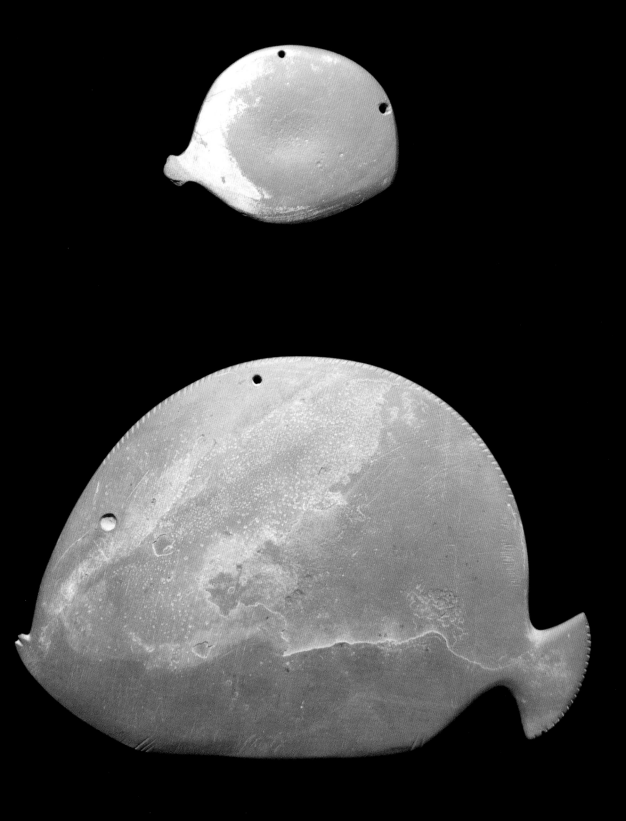

Trade on West Africa's Gold Coast

FROM THE FIFTEENTH to the late nineteenth century, gold dust was the currency of a flourishing trade on West Africa's Gold Coast (now divided between the modern nations of Ghana and Côte d'Ivoire). Remarkably diverse geometric and figurative weights were made from various alloys and used to measure specific quantities of gold dust for transactions.

In 1894, the colonial administration banned the use of gold dust as currency, and, two years later, the use and manufacture of gold weights. Many weights were subsequently sold to travellers and collectors, and in due course entered museum collections.

Gold weights formed part of an elaborate measuring apparatus formed of scales, brass or copper shovels, spoons of beaten brass with punched, stippled or engraved designs, boxes and various other types of weights such as seeds, shells, animal jawbones, gunflints, European

▼ **Leopard with a turtle in his teeth**
Length 7.2 cm
Akan; Ghana

Possibly collected by Maurice Cockin. Donated by Gordon Barclay
2010.229

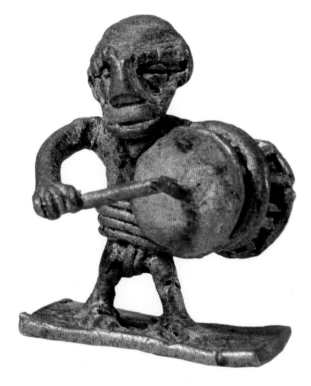

▲ Three gold weights (left to right): a man sacrificing a bird, a man smoking while carrying a barrel of gunpowder and a man beating a drum
Height 3.9 cm to 5.3 cm
Akan; Ghana

Collected by H. Nicholas, Dr A. A. Y. Kyeramateng and L. Cruise
1969.17, 1970.18, 1981.80 B

locks and keys, belt buckles, foreign money and bits of machinery. The lot was wrapped in cloth and placed in a leather bag called a *futuo*.

The gold weights and boxes were manufactured by Akan goldsmiths using the lost-wax technique, and demonstrate great skill and creativity. Some weights were cast from life, the core of clay and wax replaced by a seed, nut or an animal (a crustacean, fish or insect) thus capturing in metal the life of the natural world.

Gold weights were not only used as measuring devices; they might be worn as charms or amulets, and many illustrated local proverbs. Some depict European swords, cannons and military helmets. These tiny objects provide an extraordinary insight into Akan intellectual, economic and artistic life over four centuries.

Benin: Britain's loot

THE ART OF BENIN has been surrounded by controversy, both scholarly and political, for well over a century.

The Kingdom of Benin was one of a number of West African states that had long pre-colonial histories, complex administrative structures and an elite class that supported artisans and artists. The state was ruled over by the Oba, or divine king, who governed from Benin City, a powerful centre from 1180 until 1897 (the territory now lies within southern Nigeria).

A series of conflicts over trading rights culminated in the sacking of Benin City in February 1897 by a British punitive expedition. The Oba, Ovonramwen Nogbaisi, was exiled, though the dynasty was later re-established and remains important today. Notoriously, the occupying forces stripped the palace of bronzes, ivories and other royal insignia and art works, which were subsequently sold at auction and widely distributed among museums and private collections worldwide. In Britain, views of Benin society and culture were ambivalent. In the aftermath of the violence, Benin was denounced for its supposedly degenerate and savage propensities, but the superb quality of the bronze sculptures and plaques (cast through the lost-wax method), along with other Benin art forms, was widely acclaimed. Scholars were forced to acknowledge that great art might be created by peoples unconnected with the classical or Asian civilisations, and began to rethink the art history of Africa.

▶ **Bronze portrait of a Queen Mother**
Height 42 cm
Edo; Benin City,
southern Nigeria

Collected during the Benin West Africa Expedition, 1897.
Donated by Mrs Walter Foster
E 1902.94

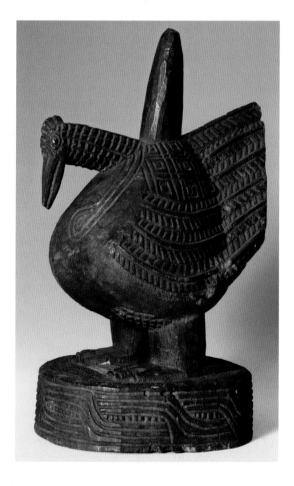

▶ **Wooden bird from a royal shrine**
Height 27.2 cm
Edo; Benin City,
southern Nigeria

Purchased at Webster's Sale, 1904
E 1904.373

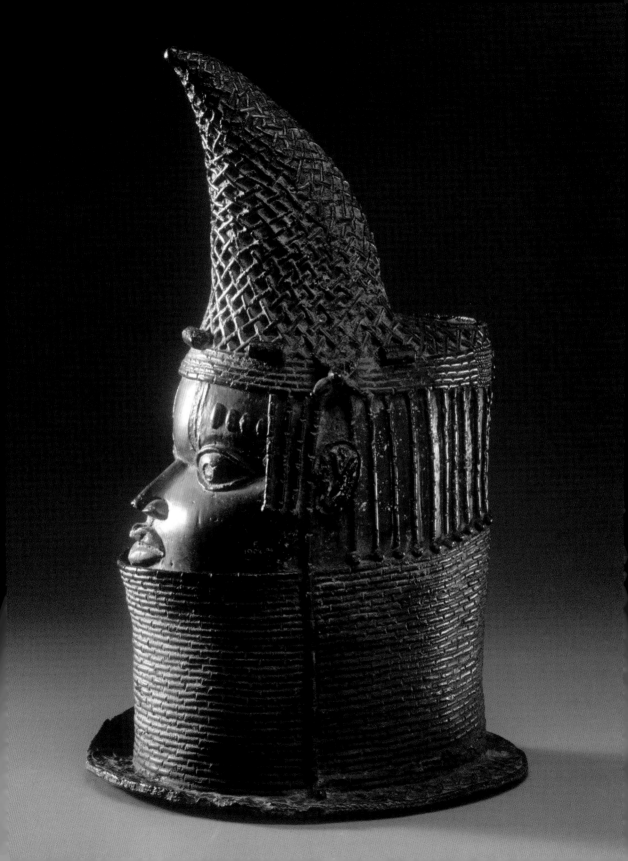

Regalia from Uganda

THE LAST YEARS of the nineteenth century were marked by dramatic change in the Kingdom of Buganda (Uganda). A period of civil war was followed by the ascendancy of chiefs affiliated with Christian missionaries and the Uganda Agreement of 1900, which created a British protectorate.

The Museum's collections from this period came through John Roscoe (1861–1932), a prominent missionary who went on to study indigenous tradition and write essentially anthropological works. His 1911 book, *The Baganda,* is widely regarded as the best early survey of customary life, but it owed much to important writings by Apolo Kagwa, Roscoe's friend and one of the Church Missionary Society's earliest converts. Kagwa was *Katikiro,* or Prime Minister, of Buganda and for 17 years Regent in place of the young heir. He and his secretary Ham Mukasa travelled to England for the coronation of

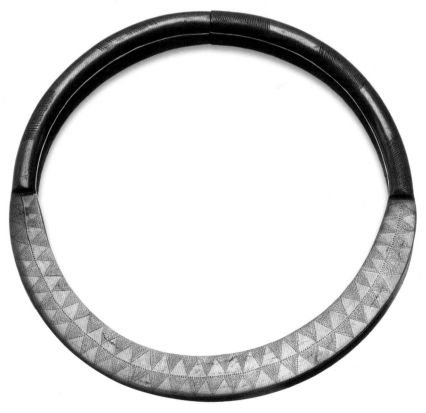

◀ **Necklet worn by royal bodyguard**
Diameter 14.5 cm
Baganda; Uganda

Donated by Sir Apolo Kaggwa,
Katikiro of Uganda *E 1903.466*

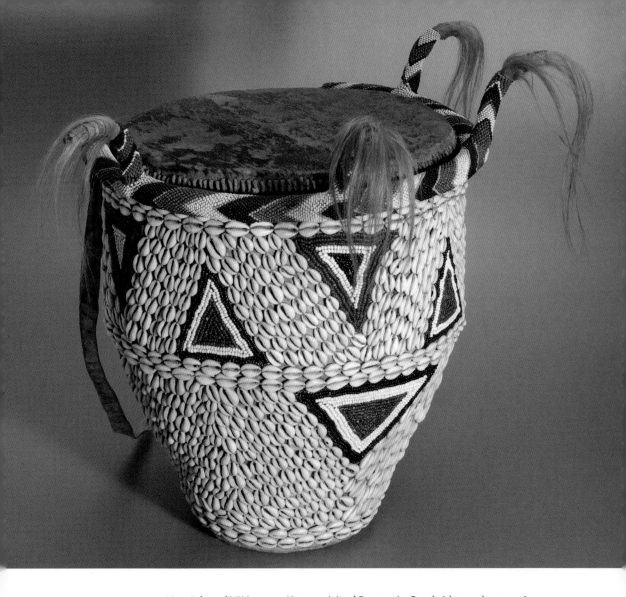

▲ Royal drum
Height 54 cm
Baganda; Uganda

Collected and donated by
Rev. John Roscoe, 1907
1920.316/Roscoe

King Edward VII in 1902. Kagwa visited Roscoe in Cambridge and gave 17 items to the Museum, including the brass necklet shown here, which would have been worn by one of the King's guards while on duty in the royal enclosure.

In nineteenth-century Buganda, drums had a multiplicity of uses, including the announcing of births and deaths, and the call to war. Among important regalia were 93 *mujaguzo* (royal drums), of which Roscoe obtained one. These were kept in a royal drum house and played suspended above the ground. Today, clans continue to be distinguished by distinctive drum tattoos (*mubala*), as are the various Christian denominations, which use drums to summon worshippers to church.

Nigerian masquerades

IN MANY SOCIETIES, art is expressed above all through performance, more so than through static objects such as sculptures or paintings. Elaborate objects are created but they are made expressly to be used in dance, drama or masquerade. Among the most famous masquerade traditions of the world are those of Igbo, Edo and Yoruba, among other Nigerian peoples. In diverse rites throughout the region, dazzling and dynamic fabric, fibre, bead and sculptural assemblages entertained crowds and were believed to placate spirits.

Gwilym Iwam Jones (1904–95) was a South African-born British colonial officer who served in Nigeria for two decades, from 1926 to 1946. At a time when few colonial officials valued indigenous culture, he became steadily

◀ **Carving a mask for the**
***Rumuji Owu* play**
Photograph by
Gwilym Jones, 1932–39
Southern Ikwerri;
eastern Nigeria

G. I. Jones Collection
N.74280.GIJ

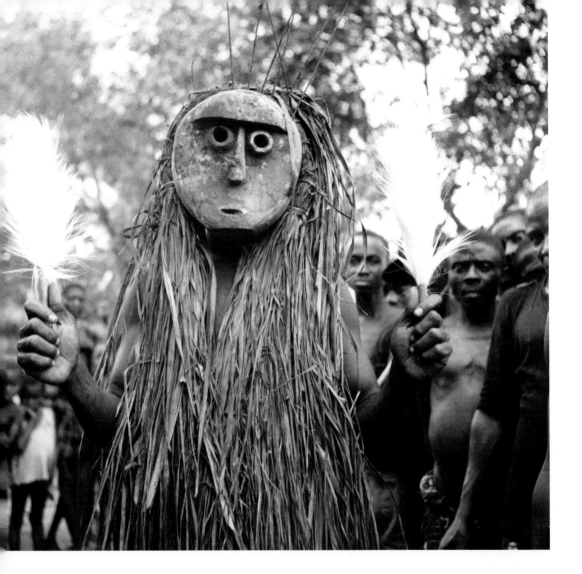

more interested in the history, society and art of eastern Nigeria, particularly among the Edo, Igbo, Ekoi and the Ibibio. He went on to publish widely, and to lecture in Social Anthropology at the University of Cambridge. He also created the single most important visual archive of the Nigerian art form.

Over 2,300 photographs reveal Jones' mastery of the photographic technique. The appeal of his images lies in their capacity to communicate actions, expressions and responses of the people photographed, be they performers or local villagers. By using natural shadows to illuminate details, by experimenting with exposure times, apertures and focal lengths, Jones captured the experience of participating in many kinds of masquerade that are rarely performed today.

Churches carved from rock

AFTER ARMENIA, Ethiopia was the second country in the world to adopt Christianity as its national religion, in the fourth century AD. A distinct form of eastern or orthodox Christianity developed in the country, and in Eritrea, that continues to flourish to this day. Though known to travellers for centuries, Ethiopian Christianity and its architecture had attracted little serious study until well into the twentieth century.

David Buxton (1919–2003) read Natural Sciences at Trinity College, Cambridge. Having specialised in entomology, he left in 1933 for Kenya and Uganda to work on locust control, went on to join the colonial service and spent the latter part of the Second World War in Ethiopia. He stayed on until 1949, fascinated by the little-known mountainous regions with their distinctive Christian traditions, and particularly by the extraordinary rock-hewn churches he found there and upon which he became an authority.

Through archaeological journals and articles richly illustrated with his own photographs, Buxton brought these churches to the attention of the outside world, and he campaigned to save the ancient church of Debra Damo from collapse.

◀ **Church functionaries at an Easter celebration**
Photograph by David Buxton, 1943–45
Adis Alem, near Addis Ababa, Ethiopia

Buxton Collection
N.54877.DBX

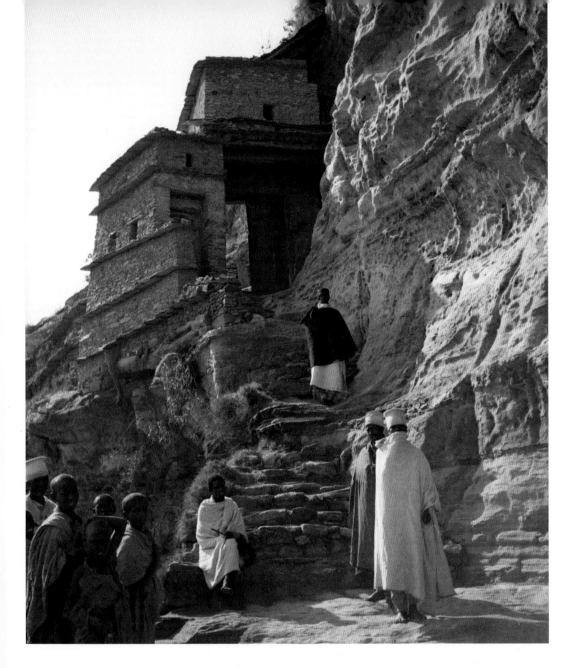

**▲ Monks on the steps
at Debra Damo**
Photograph by
David Buxton, 1944
Debra Damo, Tigray, Ethiopia

Buxton Collection
N.55147.DBX

David Phillipson, the pre-eminent scholar of Ethiopian churches (and Director of MAA from 1981 to 2006), arranged for Buxton's photographs to be gifted to the Museum in 2002. In addition to documenting the remarkable church architecture, the collection is an evocative record of local markets, people and customs, and a dramatic landscape. The complete archive was duplicated in 2006 for the Institute of Ethiopian Studies in Addis Ababa.

Self-portraits against HIV/AIDS

IN SOUTH AFRICA, the early years of the new millennium were momentous ones for those living with AIDS and for the activists who campaigned on their behalf. Members of the South African government notoriously refused to accept the scientific consensus regarding the causes of the syndrome and advocated folk remedies which lacked any medical credibility. The Treatment Action Campaign struggled to force the state to provide the life-saving medications that were being routinely prescribed elsewhere in the world.

As this campaign reached its peak, a project based in the vast informal settlement of Khaylitsha, outside Cape Town, resulted in the creation of an extraordinary series of self-portraits, or 'body maps', documenting the lives of HIV-positive women who were given access to antiretroviral drug therapies (ARVs). The body maps are life-sized images that imaginatively depict the virus and relate individuals' stories. Shadowy forms of the people who supported the women hover behind each portrait, pointing to the crucial support each person drew from those around them. Biomedical science, political claims, and moral and religious values are all represented in these remarkable images of the self caught between the fear of death and the hope of survival.

Nondumiso, one of the artists, states: 'On my picture, I drew the virus – it's the small blue dot. The white is my blood. The red circles are the ARVs eating the virus, and the virus is going down.'

▶ **Body map of Nomawethu**
Height 176 cm
Self-portrait, laser print on canvas, from an original acrylic painting (2003)
Cape Town, South Africa

Purchased by MAA from the Bambanani Women's Group
2008.21

▶ **Body map of Nondumiso**
Height 176 cm
Self-portrait, laser print on canvas, from an original acrylic painting (2003)
Cape Town, South Africa

Purchased by MAA from the Bambanani Women's Group
2008.20

The prehistory of the Levant

IN 1939, DOROTHY GARROD's appointment to the Disney Professorship of Archaeology made her the first woman to be elected to a professorship at either Oxford or Cambridge. At this time, women could study at Cambridge, through Girton or Newnham, the two women's colleges, but were not full members of the University and, until 1948, were not awarded degrees.

Garrod's reputation was built on her 1929–34 excavations of four caves in Mount Carmel, near Haifa, then in Palestine but now within Israel's borders. She was a pioneer of archaeological research in the region. The discovery of anatomically modern human and Neanderthal remains dating to the Middle Palaeolithic Period raised questions on the nature of interaction between the species, and ensures that Mount Carmel remains part of an ongoing debate concerning the survival of Homo sapiens and the extinction of Neanderthals.

Garrod's excavation produced more than 87,000 stone implements – handaxes, sickle blades, burins and cores – as well as bone tools, personal ornaments of bone and shell, and small carvings of humans and animals.

The necklace shown here is made from large shells interspersed with beads made from a deer mandible. It may be 10,000 years old.

▶ **Shell necklace**
Length 53 cm
Natufian (about
10,000 years ago)
Mugharet El-Kebarah,
Mount Carmel, Israel

Collected and donated by
Dorothy Garrod 1931.1147

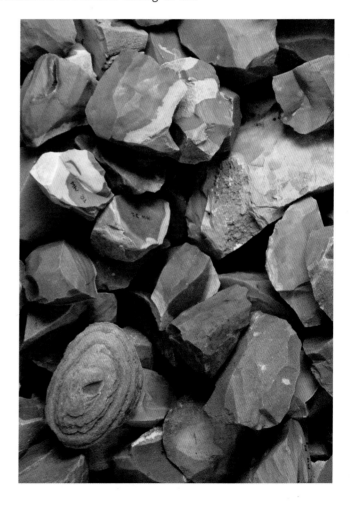

▶ **Flint, stone and quartz cores**
Length 3 cm to 9 cm
Middle Aurignacian
(about 40,000 years ago)
Level D, Wadi-El-Mughara,
Mugharet-El-Wad, Israel

Collected and donated by Dorothy
Garrod and the British School of
Archaeology at Jerusalem, 1931
Z 38161

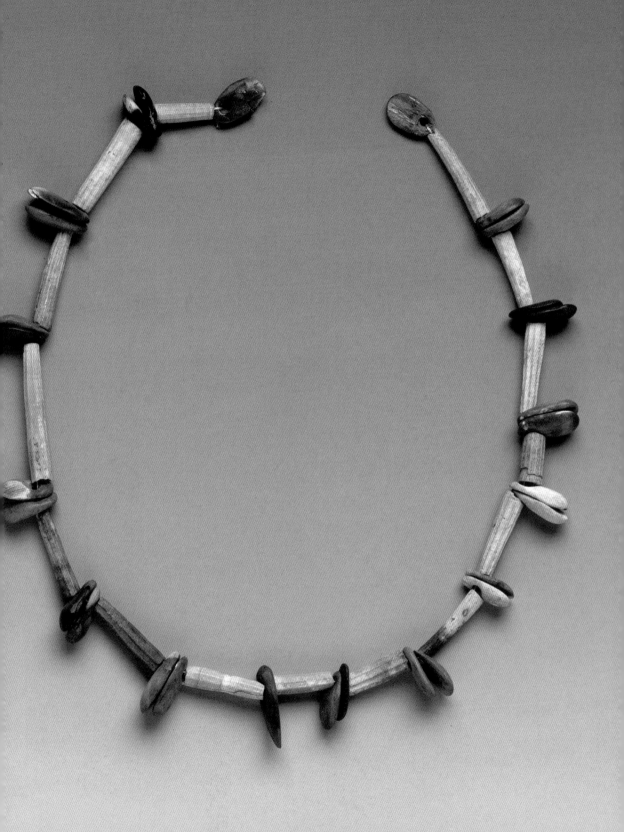

Jericho: ancient city

JERICHO HAS LONG BEEN a focus of interest to biblical historians and archaeologists because of its place in the story of Moses' successor Joshua, who brought the walls of the city tumbling down with trumpet sounds. On the basis of biblical chronology, this event should have taken place during the Late Bronze Age (c.1400 BC). Between 1868 and 1936, the site was excavated several times to determine whether the evidence supported the biblical account, with no resulting consensus.

From 1952–58, the eminent University of London archaeologist Kathleen Kenyon conducted her excavations at Jericho. Using a new stratigraphic approach, she traced the entire history of the city. The earliest evidence of human occupation dated to around 10,500 years ago, making Jericho one of the oldest cities in the world. Ultimately, Kenyon concluded that Jericho fell long before the battle described in the Bible, but her systematic method was of far broader importance than the findings from this particular site.

Artefacts from Jericho were distributed to museums around the world. MAA holds almost 7,000 objects from all periods, as well as excavation notebooks, drawings and photographs.

This plaster skull dates to 7000–6000 BC. During this period, the inhabitants of the city frequently buried their dead beneath the floors in their houses. Though some burials incorporated whole skeletons, others consisted only of the skull, remodelled with plaster to build up the facial features, and with shells set into the empty sockets to represent the eyes. Similar examples have been found with painted hair and even moustaches.

▶ **Pots from a grave**
Height 17 cm to 20.5 cm
Middle Bronze Age II
(3100–1800 BC)
Tomb G 73, Jericho,
Palestinian Territories

Collected and donated by Kathleen Kenyon and the British School of Archaeology at Jerusalem *1955.188 B & C, 1955.189, 1955.190 A, 1955.192 A, 1955.193 A, 1955.194 A & D, 1957.163*

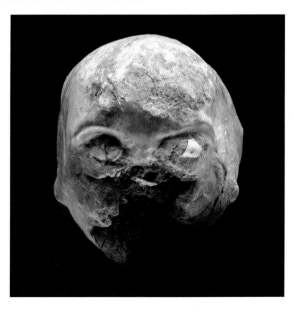

▶ **Human skull modelled with plaster and shells**
Height 15.5 cm
Prepottery Neolithic B
(7000–6000 BC)
Tell es-Sultan, Jericho,
Palestinian Territories

Collected and donated by Kathleen Kenyon and the British School of Archaeology at Jerusalem *1957.159*

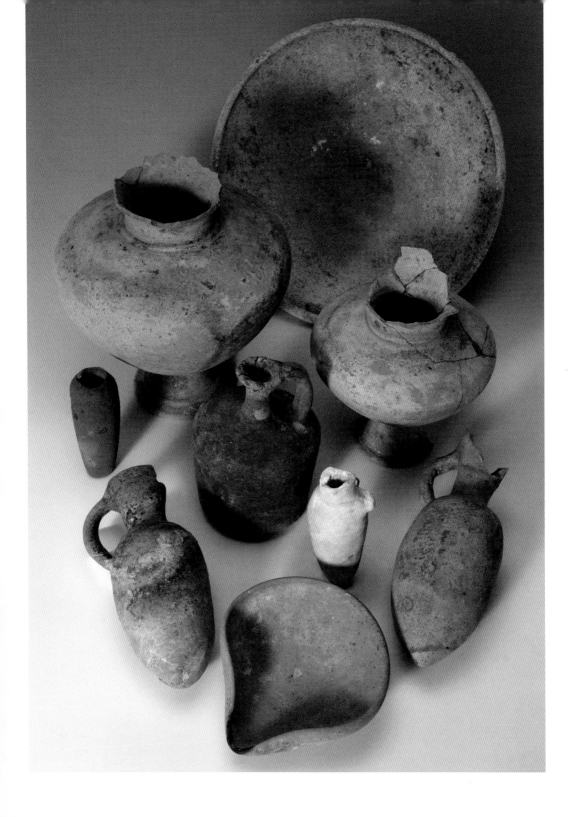

The scramble for Chinese archaeology

THE MUSEUM'S COLLECTION of ancient Chinese artefacts was largely built up in the 1930s through purchases, donations and exchanges involving Chinese and European dealers, scholars and collectors. This was the period of the Republic of China, which followed the fall of the Qing Dynasty and was brought to an end by the Sino-Japanese War of 1937–45. The Republic's government sought to transform China into a modern, democratic state. The modernising ethos of the time fostered a dramatic increase in excavations of ancient sites, often by Europeans working in partnership or competition with Chinese scholars. At the same time, the international market for Chinese antiquities boomed.

In 1932, Crown Prince Gustavus of Sweden, himself an amateur archaeologist, put together a syndicate of 20 investors in Europe that included Louis Clarke, then Director of MAA. The subscriptions financed a Swedish specialist, Orvar Karlbeck, who had spent two decades in China as a railway engineer, to travel to China and bring back antiquities. Karlbeck was recommended by the collector Oscar Raphael as having 'had remarkable success previously in securing Chinese treasures for Museums and private collections'. He described a market populated by numerous fakes of varying quality alongside authentic antiques.

Karlbreck's acquisitions were diverse, including rare neolithic ceramics from recent excavations. Artefacts from Anyang, the Bronze-Age capital of the Shang Dynasty (sixteenth to eleventh centuries BC), were fetching particularly high prices. Karlbeck was, however, able to obtain this heavily patinated bronze *ge* ceremonial axe head, which he described as typical of Anyang and rarely found elsewhere. Carbonised fragments of wood from the axe's haft still adhere to the bronze. Karlbeck bought it from a dealer in Beijing in October 1932 for $50.

▶ **Bronze *ge* ceremonial axe head**
Length 27.8 cm
Shang Dynasty (1554–1045 BC)
Chang te Fu, Anyang, Henan Province, China

Collected by Orvar Karlbeck, October 1932. Donated by Louis Clarke 1933.14

▼ **Banshan earthenware burial urn**
Height 34cm
Neolithic (about 2500 BC)
Yellow River, Henan Province, China

Donated by Louis Clarke 1936.494

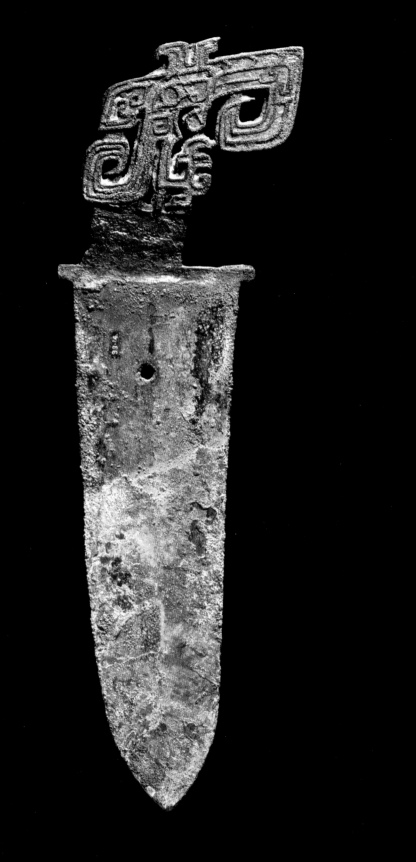

Photographing Indian archaeology

DURING THE NINETEENTH CENTURY, the archaeological exploration of South Asia was promoted mainly by the British. From the 1830s onwards, Sanskritists, lawyers, missionaries, army officers and indigo planters, among others, created their version of 'ancient India'.

At the beginning of the twentieth century, the Viceroy, Lord Curzon, and John Marshall, a Classics scholar from Cambridge and new Director of the Archaeological Survey of India, initiated an extensive conservation and excavation programme which included the establishment of the first site museums in the country. Frederick Oscar Lechmere-Oertel, formerly an engineer in the Public Works Department, investigated the site of Sarnath, now within the northern state of Uttar Pradesh, in 1904–05. During these

▼ **The reservoir at Hauz Khas after excavation**
Archaeological Survey of India, 1915–16
Hauz Khas, New Delhi, India
*Hargreaves Collection
P.16050.HRG*

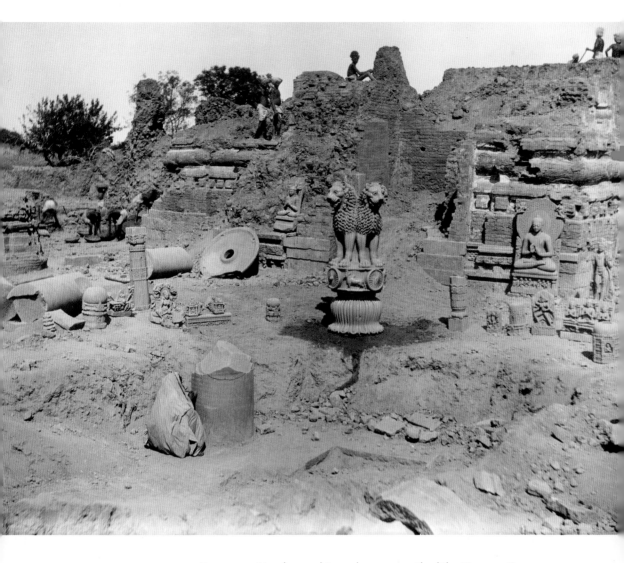

▲ **Ashokan remains at Sarnath**
15 March, 1905
Sarnath, Uttar Pradesh, India

Oertel Collection P.44599.RDG

excavations, on 15 March 1905, his workmen unearthed the Mauryan Emperor Ashoka's pillar, with its 'lion capital'. The adoption of the capital as the government emblem of independent India in 1950 is suggestive for the interplay between colonial archaeology and perceptions of heritage in post-colonial South Asia.

Since the nineteenth century in South Asia, 'doing archaeology' has meant an extraordinary range of things. MAA's photographic collections offer a window into this world of field investigation, preservation, commemoration and nation-making.

Snakes and Ladders

MAA'S ECLECTIC COLLECTIONS from South Asia include this unique wooden gaming board, inlaid with mother of pearl, which was collected by the British soldier and administrator General Richard Charles Lawrence around the time of the Indian Rebellion in 1857.

The well-known game of snakes and ladders, along with others such as chess and ludo, have their origins in India. Its invention has been traced to the poet saint Gyandev in the thirteenth century, but it may be older still. There were numerous Buddhist, Hindu and Jain variants of the game, collectively known as 'games of knowledge'. All versions shared a moral framework: lower squares represented earthly or less auspicious states of being, rising to the heights of spiritual advancement at the top

This Muslim version consists of 100 squares, each labelled in Arabic script, describing different states of being, from the lowest human condition (birth, depression, infidelity, disgrace) to the highest spiritual attainment (eternal life, the station of Muhammad). Players would move their game pieces from the first square on the bottom right, 'Adam or non-existence, to the top-most square representing the 'Arsh, heaven or the Throne of God.

Most boards, being made of paper or cloth, were fragile, and few have survived. This board is one of only three known Muslim examples from India, and the only one in wood. Little is known of the circumstances of its production – who it was made for, or by whom. It may have been made for a European, perhaps even the collector himself, or it may have previously belonged to a North Indian patron. It was doubtless a very valuable and high-status object, made with the finest materials and considerable craftsmanship.

Snakes and ladders board
Height 79.8 cm
North India

Collected by Richard Lawrence, about 1857. Donated by Mrs Henry R. Lawrence 1951.995

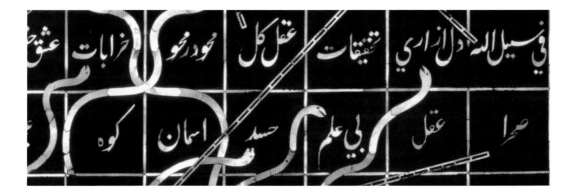

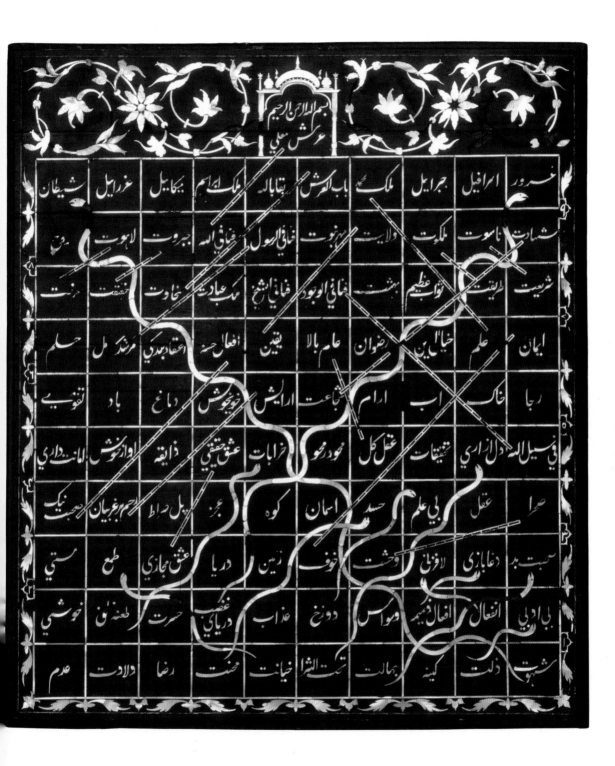

A warrior chief's shield

IN THE NINETEENTH CENTURY, Borneo was carved up between the Dutch, the Brooke Raj in Sarawak, the North Borneo Chartered Company in what is now Sabah, and the Sultanate of Brunei. Charles Hose (1863–1929) worked in the Sarawak Civil Service from 1884 to 1907 and became one of its most expert and influential administrators. He worked particularly in the extensive Baram District, a region criss-crossed by many rivers and occupied by numerous indigenous groups, including the Kayan, Kenyah, Kelabit, Lun Bawang and Penan peoples. Hose donated a diverse collection to the Museum, from sculpture and weapons to basketry, clothing and other textiles.

In the 1890s, the Baram District was in a turbulent state. It had only recently been annexed by the Brooke Raj, and customary fighting continued among the different groups of the river basin. Headhunting had been officially banned but was yet to be suppressed in practice. One of Hose's great successes was to bring warring parties together in a peace-making ceremony that was witnessed by Alfred Haddon and his fellow fieldworkers, who spent five months in Sarawak in 1899, en route back to England from their landmark expedition to the Torres Strait.

It was probably on the occasion of this ceremony that Haddon was presented with an outstanding Kenyah shield by Tama Bulan, an important chief of the Pata River. It was decorated on the back as well as the front, and featured an unusual twisted iron reinforcement; the hair incorporated into the decoration would have been taken from the heads of slain enemies. Haddon kept this daunting trophy in his study at home until about 1937, when it entered the Museum's collection.

▶ **Beaded rattan basket**
Height 45 cm
Late 19th/early 20th century
Kenyah; Long Ulai, Tinjar
River, Baram District, Sarawak

Collected and donated by
Charles Hose Z 2145

▶ **Tama Bulan's shield**
Height 140 cm
Kenyah; Pata River, Baram
District, Sarawak

Given to Alfred Haddon by
Tama Bulan, 1899. Donated
by Alfred Haddon
1937 1937.776

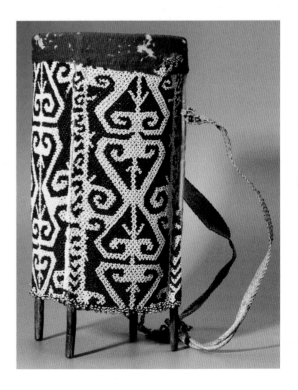

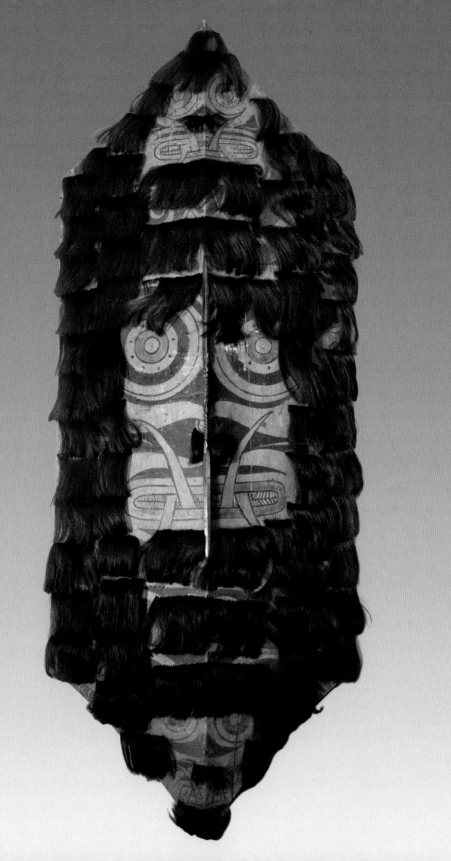

From Manchuria and Mongolia

AMONG THE IMIN NUMINCHEN people of Inner Mongolia, shamans were prominent and primarily concerned with healing, prediction and people's relationships with their ancestors. The shaman's costume shown here belonged to a young woman who died in the 1930s, aged just 25.

No two shamans' costumes are identical, and costumes were added to and enhanced as the wearer became more experienced. The main part of this garment was probably made by Dagur craftsmen, skilled at embroidery. The brass mirrors came from Chinese merchants, and the embroidered lion on the back from the woman's father's Manchu military dress. The hat that would have accompanied it was decorated with iron antlers, evoking the reindeer that populated nearby woodlands.

This extraordinary assemblage, and the remarkable horse-head lute, come from collections made in the early 1930s by Dr Ethel J. Lindgren, later a lecturer in Social Anthropology in Cambridge. She and Oscar Mamen, a Norwegian professional photographer whom Lindgren met in Ulaanbaatar and eventually married, conducted two expeditions to remote regions in northeastern Inner Mongolia (known then as Northwest Manchuria). Taking some 15,000 photographs, they aimed to produce a broad and detailed record of Mongol and Evenki peoples, as well as Russian émigrés and Han Chinese. Their images show Buddhist temples and monasteries, religious ceremonies, well-known lamas and shamans, prominent officials, common people and scenes from everyday life.

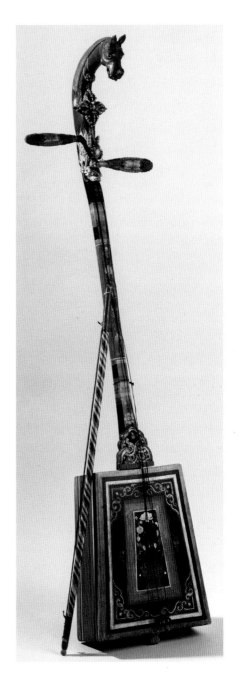

▶ **Horse-head lute**
(*morienhur*)
Height 126 cm
Ulaanbaatar, Mongolia
Purchased by Ethel Lindgren from
its previous owner, 1928
D 1939.2

▶▶ **Shaman's coat**
(*samashi*), (detail)
Length 140 cm
Imin Numinchen; Manchuria,
Northeast China
Collected by Ethel Lindgren,
March 1932
1933.37 A·B

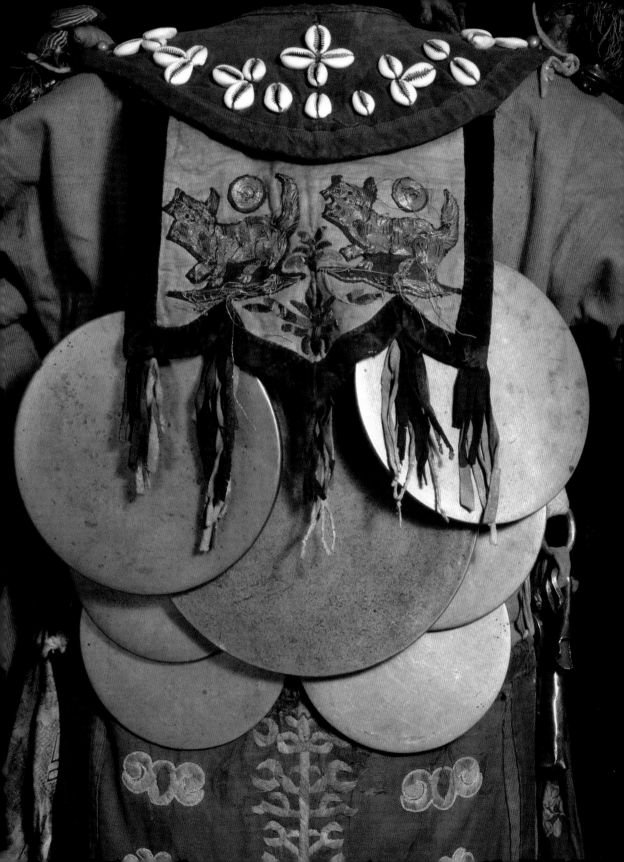

The Himalayas in the 1930s

THE FINAL PHASE of the 'Great Game' – the strategic rivalry that raged between the British and Russian Empires – was played out along the frozen mountain passes of the Himalayas. Between the two World Wars, securing political influence and accurate intelligence along the northern borders of Nepal, India and Bhutan was of paramount importance to these competing regimes. The Museum holds a unique collection of photos and films that reveal much about this period.

Taken by the Cambridge graduate Frederick Williamson, British Political Officer stationed in Sikkim, Bhutan and Tibet between 1930 and 1935, who was assisted by his very able wife Margaret, this vast collection includes thousands of photographs, gifts from royalty, such as the Bhutanese king's hat, and 29 reels of exceptional 16 mm film, the latter being Frederick's particular passion.

▼ **The Thirteenth Dalai Lama in his reception room (detail)**
Photograph by Frederick Williamson, 21 September 1933
Chense-linka, Lhasa, Tibet

*Williamson Collection
N.103781.WIL*

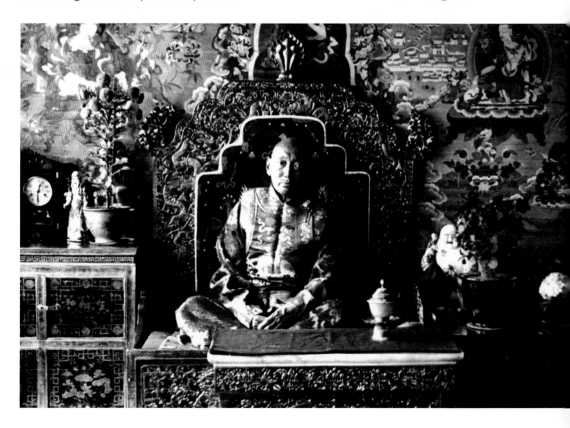

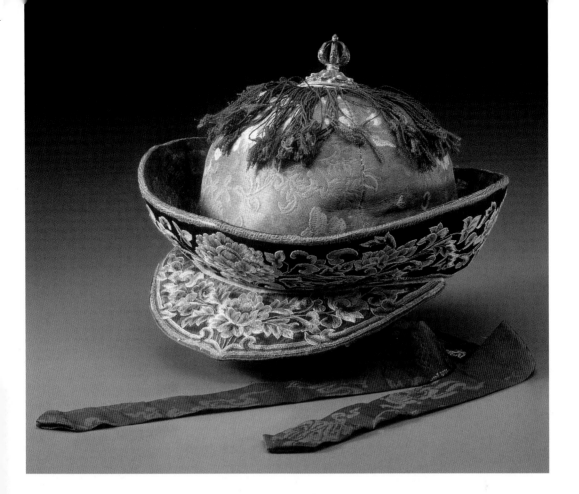

▲ **King's hat**
Height 20 cm
Early 20th century
Bhutan

Given to Frederick and Margaret
Williamson by King Jigme of Bhutan
(r.1926–52). Deposited by Margaret
Williamson *D 1976.50*

These photographic and cinematic records, enriched by journals and a published book, offer a real insight into the lives of British envoys in the last decades of the British Raj. Chronicling the Williamsons' daily activities, official duties and arduous travels, the photos and cine-films cover sites of pilgrimage, landscape and social life.

But Williamson was no grassroots anthropologist. While there are occasional images of street scenes in Lhasa, the British Officer was not there to record daily life. Rather, the Williamsons patronised the higher echelons of Bhutanese, Sikkimese and Tibetan society, and documented rituals and social occasions. The upshot is a period piece, a colonial archive that reflects a life of pomp and ceremony. Despite the distance demanded by the protocols of the Raj, increasingly relaxed poses offer a visual confirmation of the growing personal friendship between the Williamsons and members of the Bhutanese and Sikkimese royal families, as well as the Tibetan aristocracy, with whom they socialised.

The Nagas

SOME 15 DIFFERENT PEOPLES known collectively as the 'Nagas' live in the mountainous regions of northeastern India and northern Burma. Although politically part of India, the region of Nagaland, formerly known as the Naga Hills, has for centuries distanced itself from the inhabitants of lowland South Asia.

The Naga Hills was an important site of anthropological research in the 1920s and 1930s. Several colonial administrators, among them J.H. Hutton and J.P. Mills, spent years serving in the region and developed strong relationships with local people. Hutton went on to be Census Commissioner and later William Wyse Professor of Social Anthropology at Cambridge.

The Sema body-cloth collected and donated by him was worn by a man of high status. It is decorated with precious cowrie shell rings and squares of dyed red dog or goat hair; and the elaborate tassel of shells, yellow orchid stems and iridescent emerald beetle wings would be thrown over the left shoulder.

Administrators like Hutton and Mills also opened up the region to scholars from outside government service. The Austrian-born Christoph von Fürer-Haimendorf was the first professionally trained anthropologist to work among Naga peoples. At the time, headhunting remained important in

▼ **Body-cloth (detail)**
Length 155 cm
Sema; Nagaland, India
Collected and donated by
J. H. Hutton 1947.226

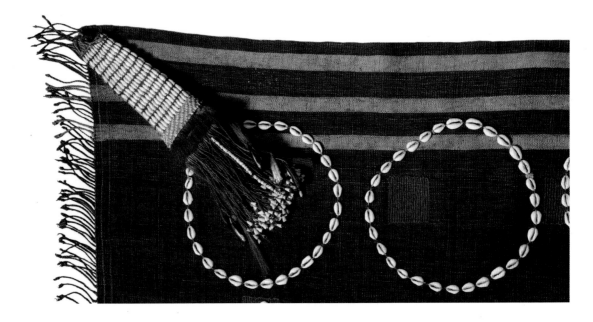

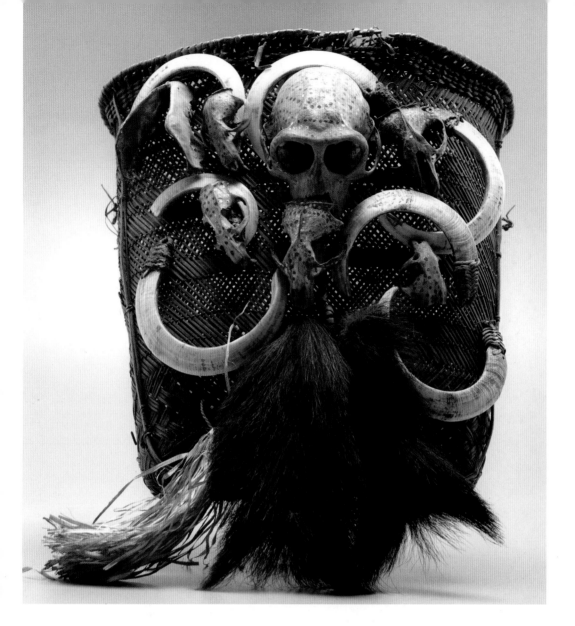

▲ Head-taker basket
Height 38 cm
Konyak; Wakching,
Nagaland, India

Collected by Christoph
von Fürer-Haimendorf.
Purchased for MAA by
Louis Clarke *1937.1041*

inter-tribal warfare, and on one occasion, Fürer-Haimendorf accompanied a British punitive expedition against a nearby village. He brought back trophies and was welcomed as a head-taker, which allowed him to document ceremonies associated with head-taking (banned under British rule). Used on ceremonial occasions, and mainly in dances, the finely woven head-taker's basket pictured here is decorated with an abundance of ornaments including monkey and rodent skulls (each painted with black and white spots), boars' tusks, tassels and bear skin.

Captain Cook's 'curiosities'

CAPTAIN JAMES COOK is commonly regarded as the greatest sea explorer of all time. His three voyages to the Pacific over the late 1760s and 1770s charted eastern Australia, New Zealand and many islands and coastlines previously unknown to Europeans.

These navigational findings were fundamental for modern geography, but the voyages were important above all for the human and cultural discoveries they led to through encounters with the diverse peoples of the Pacific and the Pacific rim. The scientists who travelled with Cook were committed to 'curiosity' – to the investigation of new things – and as interested in exotic customs and artefacts as exotic plants.

Many genres of indigenous art were first described and collected by participants in Cook's voyages. The slat armour shown here, from Prince William Sound, on what is now the coast of Alaska, was worn over a leather shirt by a warrior who would also have worn a helmet for protection. It was acquired during a short visit to the region in May 1778. One of the lieutenants wrote: 'we also bought of them a kind of armour made of long slips of wood fastened together and curiously painted'.

The arresting and enigmatic carving below is in an angular style associated with the Austral Islands, but may well have been collected in Tahiti. Possibly a prow ornament from a canoe, the significance of the piece is unknown, though double figures generally expressed divine power.

▶ **Wooden armoured shirt**
Height 53 cm
Tlingit; Prince William
Sound, Alaska

Collected on the third voyage of
Captain James Cook in 1778
1922.950 B

▼ **Carving of two human
figures and an animal**
Length 51 cm
Rurutu, Austral Islands,
Polynesia

Collected by Captain James Cook
in 1769. Deposited by the Master
and Fellows of Trinity College.
Ex Sandwich Collection
D 1914.34

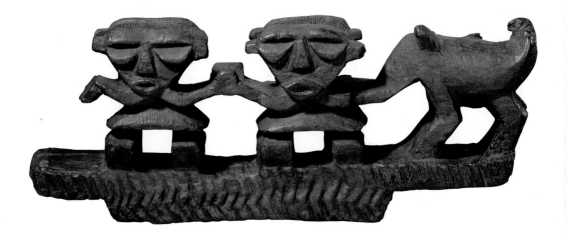

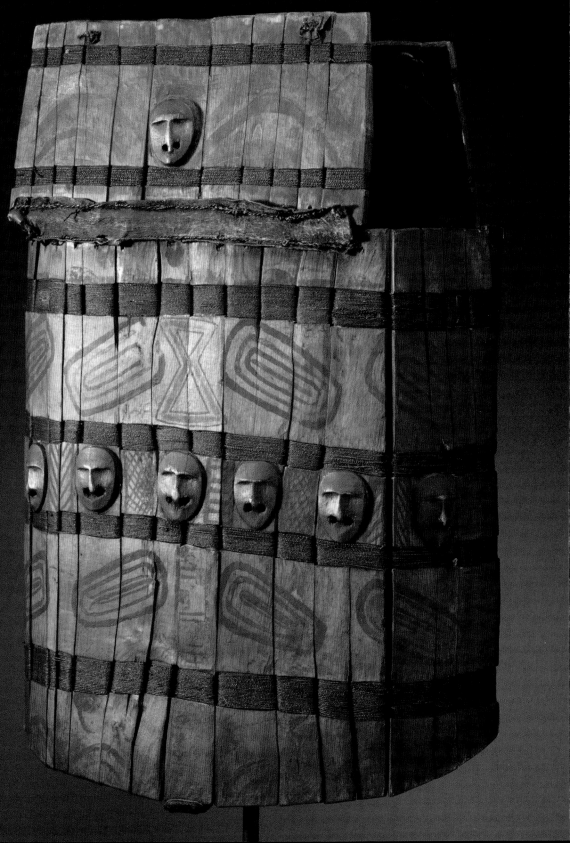

Colonialism in Australia

THE BRITISH SETTLEMENT of Tasmania in 1803 was succeeded by decades of armed conflict. Approximately 100 proclamation boards of the kind shown here were made around 1829–30 on the instructions of Governor Arthur. Inspired by bark paintings, which the colonists saw as a local medium of visual communication, they were supposed to be shown to Aboriginal people. The intention was to demonstrate that the British wanted to befriend the indigenous people, and would treat them equally before the law. Such commitments were, however, belied by a sustained campaign to capture and dispossess those Aboriginal Tasmanians who still remained on their lands.

Issues of sovereignty, history and justice remain unresolved in Australia today. Contemporary artist Brook Andrew has been especially interested in investigating anthropological collections for images and relics of his ancestors' culture. In Cambridge, he was fascinated by the drawings in an unpublished and forgotten encyclopaedia of Australia prepared after travels in the 1850s by a German naturalist, William Blandowski. In works such as *The Island*, Andrew blows such images up to billboard scale, creating spectacular monuments to indigenous sites and arts of the nineteenth century.

▶ **Proclamation Board**
Height 38 cm
Made 1829–30;
commissioned by Major-
General Sir George Arthur
Tasmania, Australia

Collected by J. Skinner Prout.
Purchased by Dr Bernard Davies
Z 15346

◀ *The Island I*
Height 250 cm
Brook Andrew, 2007

Purchased with a grant
from the Art Fund *2009.73*

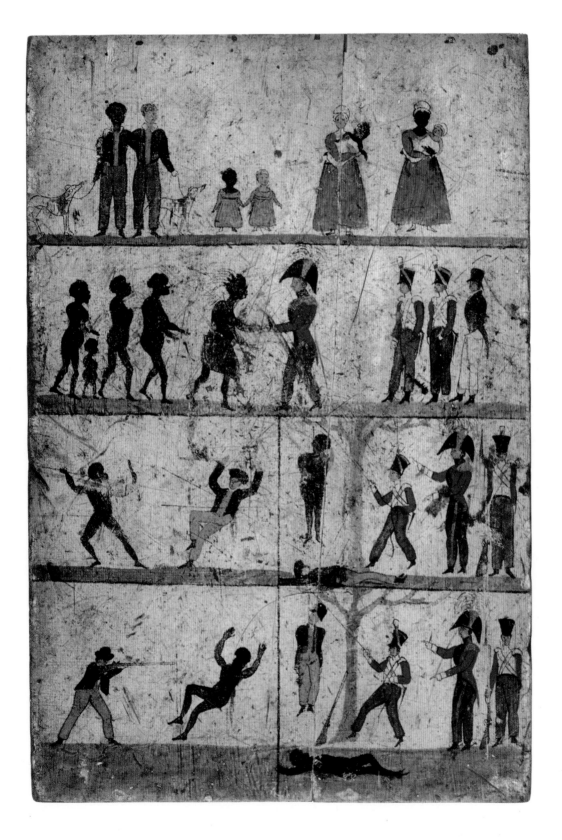

Von Hügel's Fiji

BARON ANATOLE VON HÜGEL, of aristocratic Austrian descent, travelled to the Pacific in the 1870s. An enthusiastic young natural historian, his interests shifted to anthropology soon after he arrived in Fiji in April 1875, only a matter of months after the islands had become a British colony. Von Hügel went on to spend nearly three years there, making several trips into the remote interior of the great island of Viti Levu. He was one of the first fieldworkers in the Pacific to attempt to put together a representative collection of the material culture of a particular people. His eagerness sparked off a craze for collecting among members of the Governor's household, who filled the official residence with elaborately arranged 'curios'. Important collections made by the Governor, Sir Arthur Gordon, his private secretary, Alfred Maudslay, and von Hügel himself came to the Museum on its establishment, when von Hügel was appointed founding curator.

▼ **Artefacts on display in Government House, Fiji**
October 1875
Suva, Fiji
Collection of Lady
Constance Gordon Cumming
P98954.GCUM

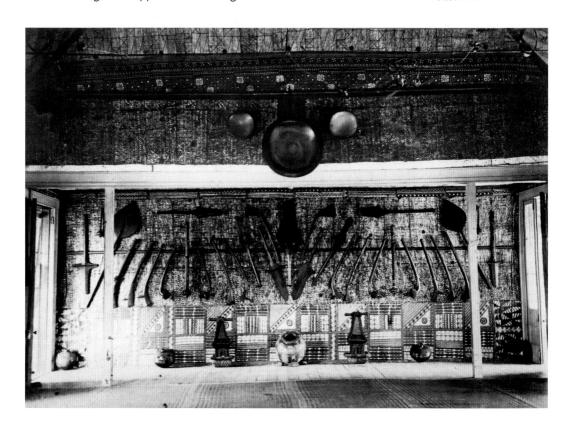

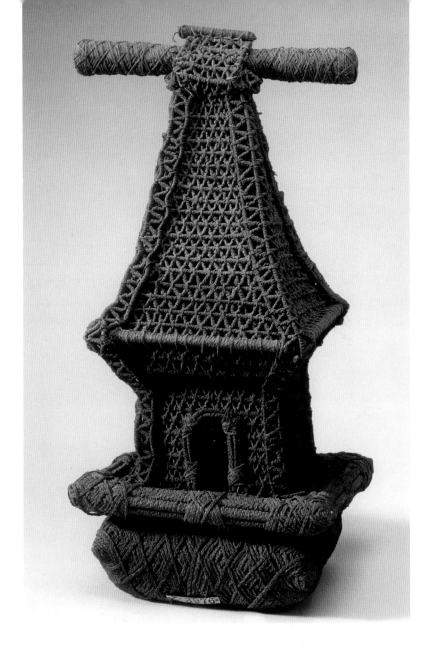

▶ **Model spirit house**
Height 55 cm
19th century
Fiji

Collected by Anatole von Hügel,
before 1875
Z 3976

This beautiful and intricate *bure kalou*, or spirit house, was woven out of some hundreds of metres of sinnet (coconut fibre), a cord widely used in the Pacific for the binding of sacred as well as ordinary objects. It reproduced the form of a full-size Fijian temple and may have contained one or more small carved images of gods. Model spirit houses of this kind, vital to the ritual lives of communities, were traded with collectors after the Fijians converted to Christianity during the 1860s and 1870s.

Crocodile into man

THE TORRES STRAIT IS LOCATED between Cape York, Australia's northern extremity, and New Guinea. The peoples of the islands within the strait had links to both south and north but were predominantly Melanesian, and most strongly affiliated with neighbouring groups along the south coast of New Guinea. Artistically, the islands are celebrated for the production of elaborate turtle-shell masks, first observed by the Portuguese explorer Luis Baés de Torres in 1606.

This elaborate composite mask (*krar*), with a crocodile head surmounted by a human face, was ingeniously crafted to surprise and captivate audiences. When worn upright over the top of the head only the crocodile was visible, but during the performance, the bearer would abruptly bend down to reveal the human face. Made from carefully moulded plates from the carapace of the hawksbill turtle, the mask is decorated with cowries and goa nuts, cassowary feathers from New Guinea and orchre traded from Cape York. Incised details are highlighted with lime, and valued European materials – the iron used for the outstretched hands and strands of calico – were also incorporated.

The mask is known to have been made by a man named Gizu, and it was collected by Alfred Haddon on Nagir in August 1888. Haddon returned to the Torres Strait ten years later as leader of the 1898 Cambridge Anthropo-

▶ **Turtle-shell mask**
Length 55 cm
Made by Gizu
Torres Strait,
Queensland, Australia
Collected by Alfred Haddon, August 1888. Donated by Arthur Gordon 1890.182

◀ *ULAKAL*
Height 70 cm
Alick Tipoti, 2002
Torres Strait,
Queensland, Australia
Commissioned by
Anita Herle for MAA
2005.86

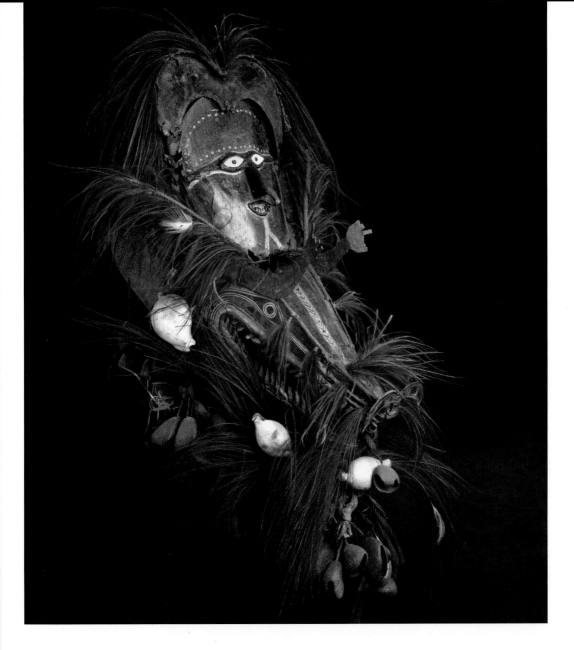

logical Expedition, which was a major influence on the professionalisation of anthropology in Cambridge and beyond.

Contemporary Torres Strait Islander artist Alick Tipoti has researched historical Torres Strait objects at MAA and in other museum collections as an inspiration for his own printmaking. He has compared his working of the linoleum block to skills formerly employed for carving and incising drums and masks.

A Maori flagpole

TENE WAITERE (1854–1931) was the most important Maori sculptor of the colonial period. He acquired his skills in a traditional school near the town of Rotorua in New Zealand's hot lakes district, and worked on customary carved houses for his tribe and for other Maori. He also produced a host of innovative works for colonial collectors and for ethnological museums.

In the mid-nineteenth century, the Maori became interested in symbols of European sovereignty. They created tribal flags and began also to carve flagpoles, which often stood beside their great meeting-houses. This *pouhaki*, or flagpole, formed part of a gift to Edward, Prince of Wales, who visited New Zealand in 1920. He brought it back to England and it was erected in gardens at HMS *Excellent*, a Royal Navy shore base in Portsmouth Harbour.

In 2007, Nicholas Thomas, the Museum's Director, became aware of the flagpole's existence. He contacted Tene Waitere's family, who supported the *pouhaki's* move to Cambridge. James Schuster, Tene's descendant and an expert in the restoration of historic carvings, travelled to Britain to bless the process of moving the *pouhaki*, and to undertake conservation work on it. The *pouhaki* now in Cambridge is the only one outside New Zealand and may be the earliest extant anywhere.

◄ **James Schuster restoring his grandfather's flagpole**
Autumn 2007
Museum of Archaeology
and Anthropology

► **The flagpole welcomed at MAA, 4th December 2008**
Height 800 cm
Made by Tene Waitere

Given to Edward, Prince of Wales, 1920. Deposited by the Ministry of Defence 2010.672

One village, two anthropologists

GREGORY BATESON (1904–1980) was one of the most creative and influential anthropologists of the twentieth century. Initially trained in biology, he was encouraged to turn to anthropology by Alfred Haddon. Bateson conducted intensive field research with the Iatmul peoples of the middle Sepik region in Papua New Guinea from 1929–30 and 1932–33, and in 1935.

This field photograph includes a few of the several hundred objects collected by Bateson for the Museum, including shell ornaments and a *mwai* mask with a characteristic serpentine nose, cowrie shell eyes, a conus disc on the forehead and boars' tusks. Each mask of this type has a personal name specific to a clan, and may be shown publically, but has sacred meanings known only to a few initiates.

Andrew Moutu, a Papua New Guinean anthropologist, conducted fieldwork in 2001–02 in Kanganamun, the village that had been the site of Gregory Bateson's research. This sculpture represents an initiate, a *bandi*, resting his head on his maternal uncle's lap as his skin is ritually scarified; the process takes place on an upturned canoe. It was commissioned by Moutu for the Museum, and carved, following appropriate ritual observances, by Raymond Amisongmeli, Luke Kamangari, James Lanjinmeli, Albert Lumutbange, Ben Mafa and David Yamanafi, all of whom are members of the Wolimbi men's house in Kanganamun village. Scarified initiates are seen to be devoured by a crocodile, that they may be reborn as true men.

▶ *Bandi* **sculpture (detail)**
Length 146 cm
Carved by
Raymond Amisongmeli, Luke Kamangari, James Lanjinmeli, Albert Lumutbange, Ben Mafa and David Yamanafi
Iatmul; Kanganamun village, Sepik River, Papua New Guinea
Collected and donated by Andrew Moutu 2002.89

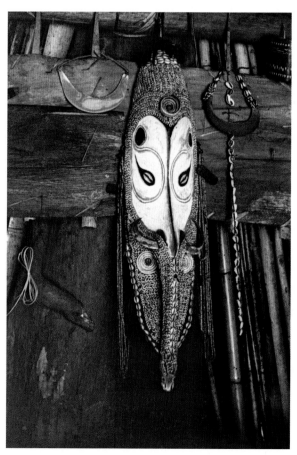

▶ *Mwai* **mask and shell ornaments in a men's house**
Photograph by
Gregory Bateson, 1932
Kanganamun village, Sepik River, Papua New Guinea
P.16712.BAT

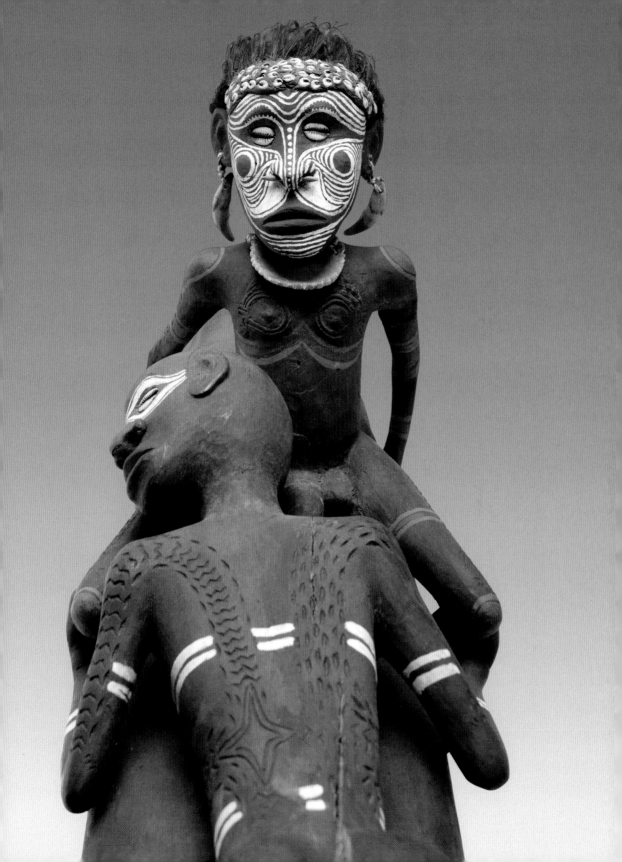

Biting the Doctor's Arm

MATHIAS KAUAGE (*c*.1944–2003) was a founding figure of modern art in the Pacific. A Chimbu man from the Highlands of Papua New Guinea, he was one of a number of painters, printmakers and sculptors supported by Georgina Beier, herself a painter and influential as a catalyst for modern art in both Africa and the Pacific. An important group of early works by Kauage and other modern Melanesian artists was gifted to the Museum in 2008 by Dame Marilyn Strathern, William Wyse Professor of Social Anthropology (1993–2008), who conducted fieldwork in Mount Hagen in the Highlands and among Hagen migrants in the capital, Port Moresby, from the 1960s onwards.

While Kauage's contemporary, Timothy Akis, depicted creatures from his imagination as well as familiar New Guinea birds and animals such as cassowaries and flying-foxes, Kauage embraced modern and urban subjects –

▼ *Biting the Doctor's Arm*
Length 175 cm
Mathias Kauage, 1990
Papua New Guinea

Purchased with a grant from
the Art Fund *2010.364*

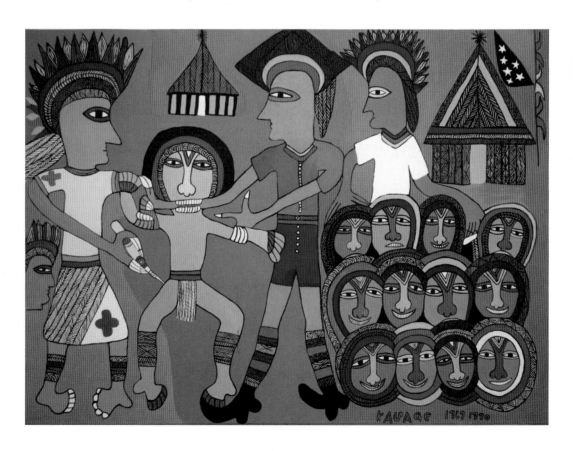

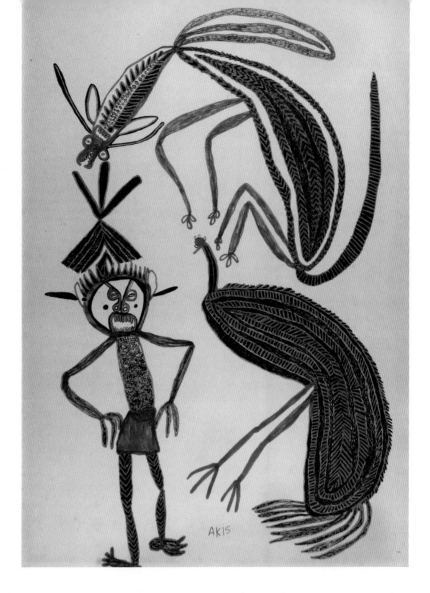

▶ Untitled drawing
Height 82.5 cm
Timothy Akis, 1970s
Papua New Guinea
Donated by Marilyn Strathern
2009.43

buses, helicopters, political events. He also depicted Papua New Guinea's history and colonial experience. *Biting the Doctor's Arm* portrays the artist's own resistance to having an injection whilst at primary school. In one sense, the experience is universal – the fear of a jab that a child anywhere in the world might experience – in another, it is particular: the painting depicts an encounter between colonial Australian medical staff and Melanesian children.

Kauage was not a traditional artist but he saw whatever he painted from a Highlands perspective. His figures are brightly dressed, wearing ceremonial headdresses and adorned like dancers, who traditionally represented their people's power and splendour.

Peruvian textiles

ARCHAEOLOGY OFTEN PRODUCES evidence of the tools people used, the food they ate and the gods they worshipped, but because textiles are inherently perishable, we seldom have a sense of the clothing people wore. In Peru, however, fabrics survive in large numbers both as a result of the arid coastal conditions, and for the fact they were so valued by ancient Peruvians. Textiles played an important role in life as well as in the burial of the dead: bodies were often wrapped in many layers of fabric, sometimes up to 25 metres long.

Over the course of several thousand years, textile patterns, types and iconography have varied greatly. This poncho and headdress from the Chimu culture (900–1470 AD) are decorated with alternating patterns of birds (possibly owls) and fish (possibly rays) using white, brown, red and green feathers. They were said to be found on an entombed mummy near modern Trujillo but, like many examples collected in the early twentieth century, they were not excavated by archaeologists, so we cannot be completely sure.

The small textile fragment below is associated with the Nazca culture (1–750 AD) and is possibly the border and fringe of a shawl. It features semi-human figures with claws for feet and strange faces, who wear brightly coloured and intricately patterned textiles of their own.

▶ **Feather poncho and headdress**
Height (poncho) 80 cm
1000–1500 AD
Chimu; Trujillo, Peru

Collected by A. E. Macandrew.
Transferred from Colchester
Museum 1947.302 A & B

▼ **Border of a shawl (detail)**
Height 8 cm
200 BC–600 AD
Nazca; Paracas, Peru

Purchased from Puttick and
Simpson's sale, 5 October 1933.
Donated by Louis Clarke 1933.681

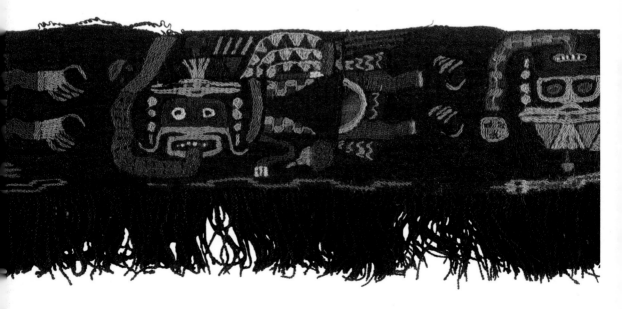

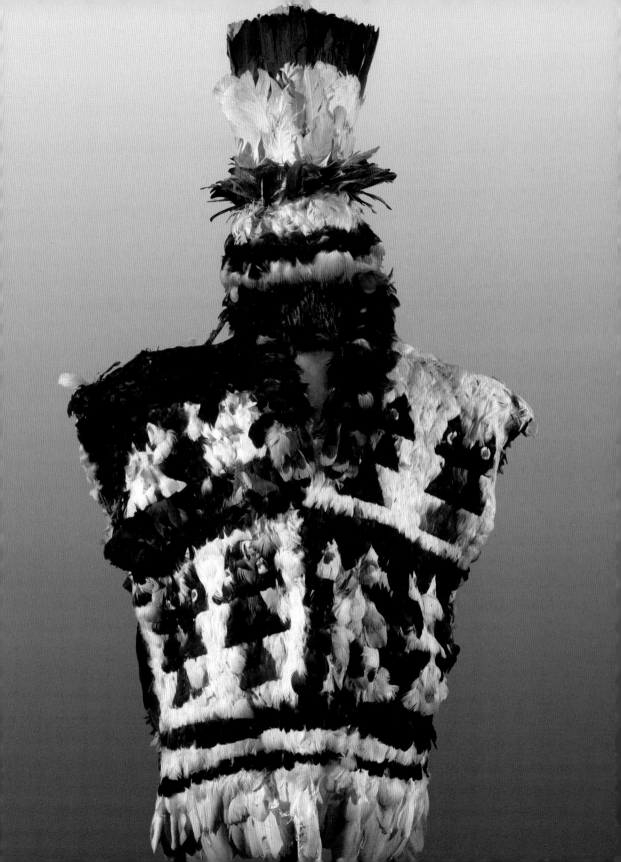

Precolumbian ceramics

THE MUSEUM'S COLLECTION of Precolumbian pottery from South America is the largest and most comprehensive in Britain.

Perhaps most famous are the ceramic vessels from the Moche culture, which thrived in the valleys of Peru's northern coast from the first to around the seventh century. Enormous numbers of this instantly recognisable red and white pottery were produced by Moche craftsmen, sometimes using moulds to allow for mass production; they added details by hand, so that it is sometimes possible to identify the work of an individual artist. Many pieces are portraits of individuals, or represent figures such as warriors, priests or prisoners. They include scenes of human sacrifice, sex, drugs and music, as well as representations of illness, hunting and shamanism.

The vessel opposite depicts a jaguar holding a warrior captive. The jaguar, being a powerful animal, was often employed as a symbol of a god's power. The vessel's stirrup spout takes air in as liquid is poured out, often producing a distinctive sound in the process – perhaps something like the roar of the fearsome beast itself.

For centuries, vast numbers of these pots have been 'mined' from tombs by local and foreign looters. Many in the Museum's collection were donated by Louis Clarke, who was Director of MAA from 1922 to 1937 and had conducted excavations in New Mexico. Most pieces he purchased through sale rooms and auction houses, severed from their archaeological context. But the sheer quantity of surviving specimens, and the distinctive artistic styles, make them valuable evidence for scholars researching this ancient civilisation.

▶ **Vessel of a man and a jaguar**
Height 19.5 cm
100–600 AD
Moche; Trujillo, Peru
Donated by Louis Clarke *1924.225*

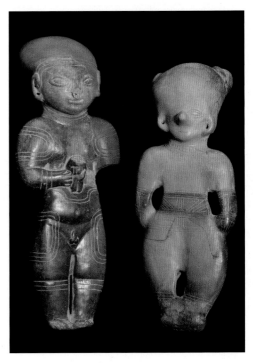

▶ **Clay figures: man holding a baby (left) and anthropomorphic whistle (right)**
Height 30.5 cm and 28.4 cm
Gangala and Engoroy cultures
(300 BC to 800 AD), Ecuador
Donated by George Sheppard and Geoffrey Bushnell
1931.478, 1936.665

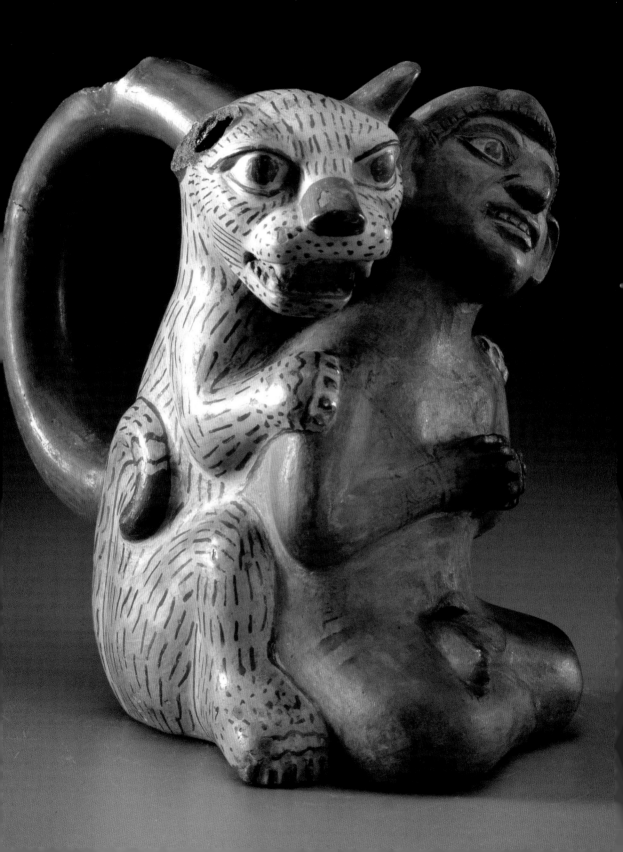

Maudslay's Mayan casts

AMONG THE FIRST OBJECTS accessioned into the Museum's collections were a group of monumental plaster casts of Mayan sculpture taken in the sites of Quirigua in Guatemala and Yaxchilan in southern Mexico. They were donated by Cambridge graduate and sometime colonial officer, Alfred P. Maudslay (1850–1931).

The casts had been made in April 1884 by a London-based Italian craftsman, Lorenzo Giuntini. Giuntini joined Maudslay's pioneering expeditions to ancient Mayan sites in Central and North America, making moulds of the monuments and producing complete casts on his return, which were sent to several museums in Britain and the United States. Among the Cambridge casts are sculptural reliefs from the city of Yaxchilan and stelae from Quirigua, one of which (known as 'stela E') is said to be the largest piece of stone ever quarried by the ancient Maya, measuring over 8 metres in height. The original Yaxchilan sculptures are now in the British Museum. The Quirigua stelae remain where Maudlsay found them, in what is now a World Heritage Site.

▶ **King Bird Jaguar IV with a prisoner (lintel 16, structure 33)**
Height 88 cm
About 769–800 AD
Maya; Yaxchilan, Mexico
Commissioned by King Bird Jaguar IV, completed by his son Itzamnaaj Balaam III.
Plaster cast by Lorenzo Giuntini, 1884

Donated by Alfred Maudslay 1885.3

◀ **Stela of K'ak' Tiliw Chan Yopaat on display in the Maudslay Hall (detail)**
Height 840 cm
Maya; Quirigua, Guatemala
Commissioned by K'ak' Tiliw Chan Yopaat (r.724–785 AD). Dedicated 24 January 771.
Plaster cast by Lorenzo Giuntini, 1884

Donated by Alfred Maudslay.
Photograph by Gwil Owen, November 1978 1885.3

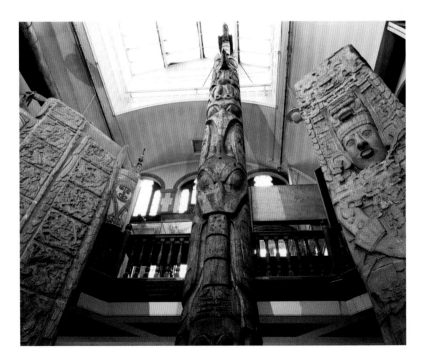

Maudslay's collections and studies led to the decipherment of Maya hieroglyphs over the course of the twentieth century. Today, the casts are of value both as objects of Mayan culture as well as being expressions of a moment in the history of archaeology. In the years since Maudslay's expeditions, the monuments have suffered erosion and exposure, while the casts retain details now missing from the originals. The casts also reflect ethical and practical issues: unlike many nineteenth-century archaeologists in the Middle East, Maudslay worked primarily by producing casts rather than by removing original monuments to Britain.

A naturalist's collection from southern Mexico

IN 1930, THE MUSEUM received through Cecil Baring, an aristocratic banker and enthusiastic naturalist, the collections of the late Hans Gadow. Gadow was a German-born zoologist who had settled in England, working first at the British Museum and later the University of Cambridge. Between 1902 and 1904, he travelled through the southern part of Mexico, observing the country's flora and fauna, as well as its human population, and he put together a large collection of artefacts, both ancient and relatively new.

Almost all of the objects Gadow collected were found above ground, purchased or traded from local people, rather than excavated. His collection is quite eclectic and certain objects defy easy classification. The highly weathered stone statue shown opposite is one such enigma. In his account of his journeys, *Through southern Mexico*, Gadow recounts his discovery of the slab in the city known today as Xochicalco, near Cuernavaca. He describes it as a goddess known as a La Malinche, 'the name of that romantic native girl who acted as Cortez's faithful interpreter, spy adviser and wife'.

When it entered the Museum's collection, the statue was identified as Xilonen, or Chicomecoatl, the Aztec goddess of young maize, because of the rosettes on the side of her headdress and the heads of corn she carries in her hands. But there is great scope for confusion. Although the city of Xochicalco predates the Aztec Empire by several hundred years, many of the cultures of the region shared deities and depicted them in similar ways. Without archaeological context, we cannot be sure who it represents or who made it.

▶ **Statue of Chicomecoatl, goddess of young maize**
Height 41 cm
650–900 AD
Cerro de la Malinche,
Xochicalco, Mexico

Collected by Hans Gadow, 1902–04.
Donated by Cecil Baring,
Lord Revelstoke *1930.1220 A-B*

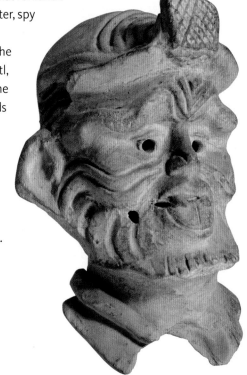

▶ **Terracotta head of a Spanish soldier**
Height 14.5 cm
Cuernavaca, Mexico

Collected by Hans Gadow, 1902–04.
Donated by Cecil Baring,
Lord Revelstoke *1930.1188*

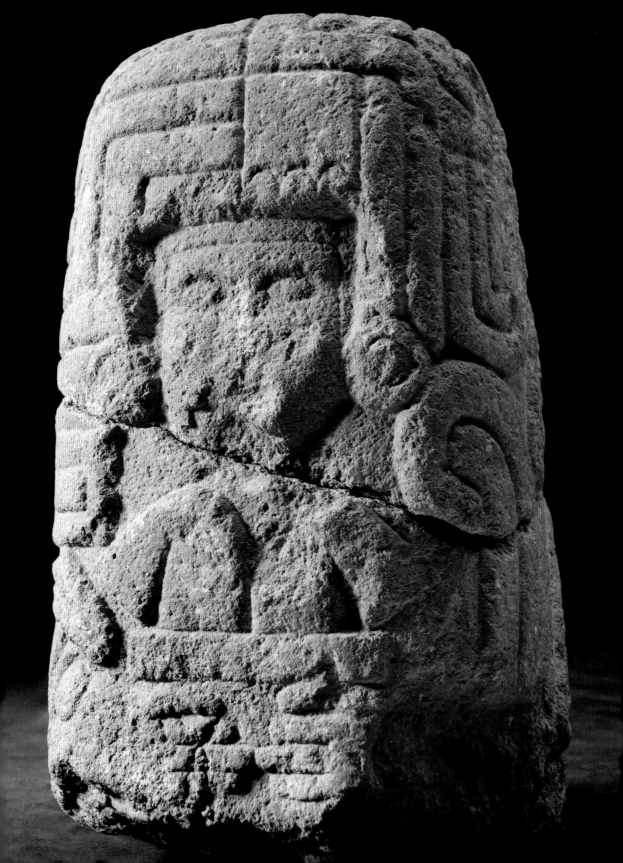

North American plains and woodlands

THIS SMOKED MOOSE-HIDE coat embodies complex social relations. Made by a Cree-Métis woman, it reflects both her Native and European heritage. The overall shape, and the use of epaulets, is based on a European style, while the painted decoration and loom-woven porcupine quillwork draws on traditional designs. Worn by European and Native men, coats like this were made by women as gifts for their husbands or else traded to prestigious visitors. The pristine state of this particular coat suggests that it was never worn. It was collected between 1818 and 1822, along with moccasins, a bag and gloves, by William Woodthorpe Cobbold, an accountant for the Hudson's Bay Company's fur trade fort at Moose Factory.

The image of a warrior on horseback armed with a bow and arrow has become emblematic of Plains culture. Men often painted events from their dreams or battle experiences onto their clothing and other possessions, and the scene on this drum may refer to a specific incident. The drum is part of a collection of over 100 objects made by American folklorist Mary Owen, who worked with Meskwaki (Sac and Fox) people in Iowa and recorded many of their stories. Encouraged by Alfred Haddon at Cambridge, she presented her collection to the British Folklore Society in 1898, and it was deposited at MAA in 1901.

▶ **Moose skin greatcoat**
Length 118.3 cm
Woodlands Cree;
Hudson Bay, Canada

Collected by William Cobbold Woodthorpe. Donated by Mrs Barry
1934.151

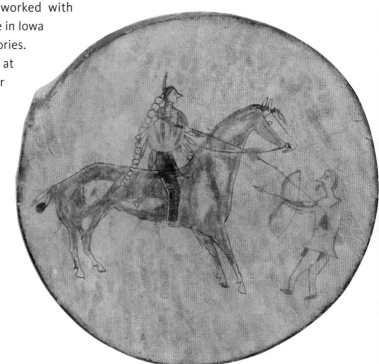

▶ **Dancer's drum**
Diameter 21 cm
Plains: Meskwaki;
Great Lakes, USA

Collected by Mary Owen.
Ex Folklore Society Collection
D 1976.208

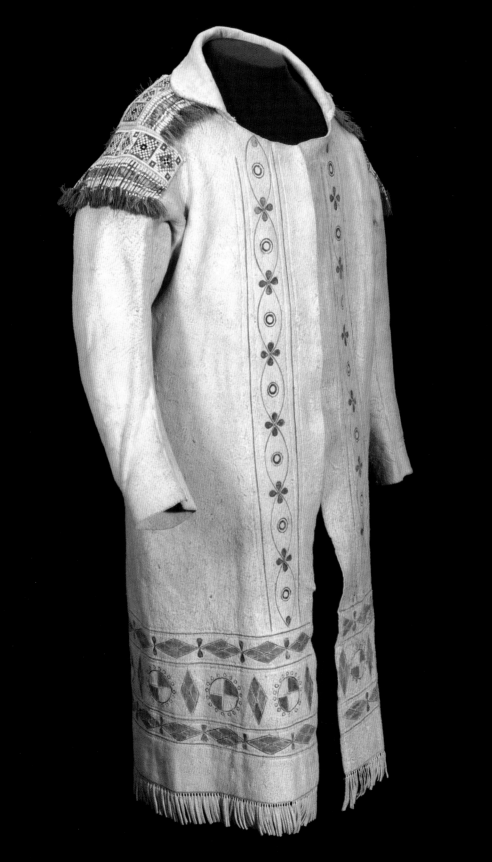

The Day of the Dead

THE MEXICAN DAY OF THE DEAD is an annual festival in which the living celebrate the souls of the dead. The rites and observances connected with the festival have a Prehispanic history but came to be associated with the Catholic holidays of All Saints Day and All Souls Day (1 and 2 November). Families prepare offerings of food and drink that are placed beside photographs of deceased relatives on household altars decorated with flowers and candles; graves are cleaned and decorated, and various public celebrations are held. The rich associated art tradition included the making of sculptures, sugar skulls, paper cut-outs and games, often featuring comical depictions of skeletons (*calaveras*) engaged in everyday activities.

Frederick Starr (1858–1933) was Curator of Ethnology at the American Museum of Natural History in New York and a founding figure in anthropology at the University of Chicago. In the 1890s, he put together a large collection of Mexican ethnography for the British Folklore Society which

▼ **Votive painting (*matraca*): Apparition of Our Lady of Lourdes**
Height 18 cm
Leon, Mexico

Collected by Professor Frederick Starr, 1898
Folklore Society Collection Z 39780

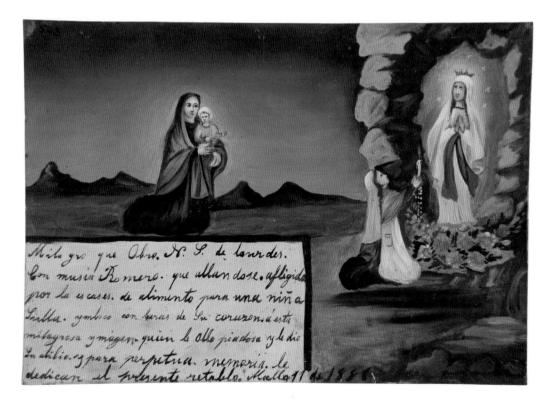

▲ Model of funerary procession
Height 7 cm
Morelia, Mexico

Collected by Professor
Frederick Starr, 1898
Folklore Society Collection Z 39902

came to the Museum in 1899. It includes some of the oldest surviving objects associated with the festival. Shown here is one of several funeral processions, composed of paper figures with chickpea heads.

The collection also featured other popular arts. Paintings on tin were often hung on household walls with flowers or candles. They represented both foreign saints such as our Lady of Lourdes as well as locally famous Mexican *santitos,* and were thought to have the capacity to protect and heal.

A Haida totem pole

TOTEM POLES EMBODY histories and lineages associated with particular individuals, families and communities. These monumental sculptures were typically raised at potlatches – lavish feasts in which the hosts asserted and substantiated their social and spiritual status. The intermingling of animal crest designs with human figures expressed the idea of transformation, fundamental to the culture and art of the peoples of the American Northwest Coast. At the top of the pole, an eagle sits on a set of rings, each of which represents a potlatch; the rings in turn rest upon a hat, which was a customary symbol of wealth and prestige. Beneath the carving features another eagle with a smaller bird – possibly a raven – on its chest, a cormorant, a killer whale and a human figure. At the bottom of the pole is a beaver with a cross-hatched tail holding a chewing stick.

This pole was bought for the Museum by J. W. L. Glaisher, a mathematician, Fellow of Trinity College, and an enthusiastic collector and donor. He had visited British Columbia and brought back many objects for the collections, but the pole was obtained later, through Charles Frederic Newcombe, an ethnographer who had worked as an agent for the British Columbia Provincial Museum in Victoria. It reached the Museum early in 1926. Installed in April of that year, it has been one of the Museum's most iconic objects ever since.

▶ **Totem pole on display in the Maudslay Hall**
Height 1400 cm
Haida; Tanu, Moresby Island, Queen Charlotte Islands, British Columbia, Canada

Collected by Dr Charles F. Newcombe, 1925. Donated by Dr J. W. L. Glaisher *1926.225*

▼ **Totem poles in Tanu (detail)**
Photograph by Dr Charles F. Newcombe, 1900
Tanu, Moresby Island, Queen Charlotte Islands, British Columbia, Canada

P.47400

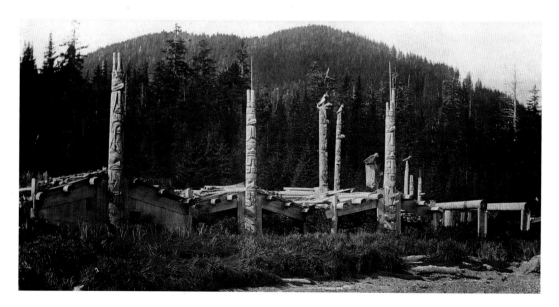

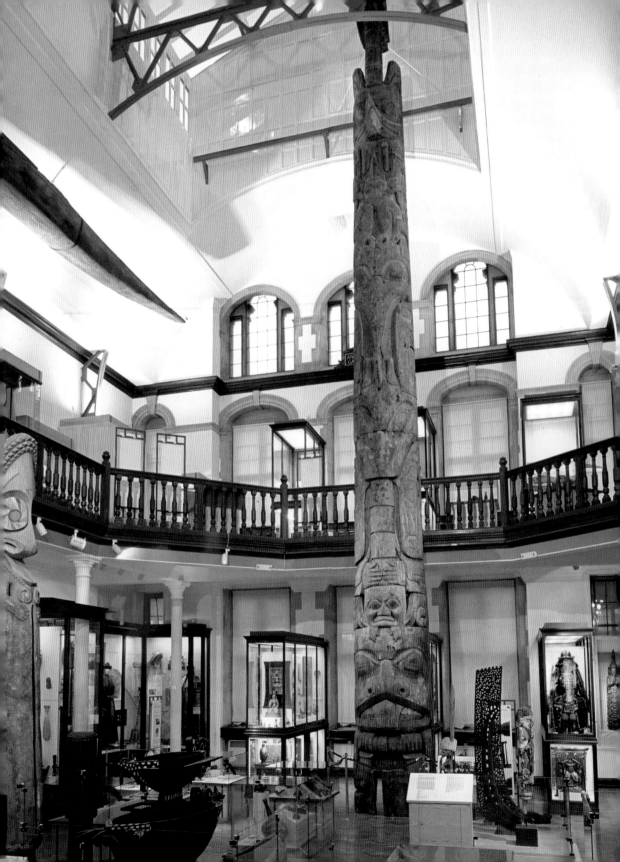

Arctic Greenland and Nunavut

THE 1930S WERE A TIME of major upheaval for the Inuit populations of both Greenland and Baffin Island. Some moved to permanent settlements, while others tried to maintain their nomadic way of life. Missions, commercial enterprises and governments in various ways pressured the Inuit to abandon their extraordinary life-ways that were so well fashioned to the Arctic environment.

During the 1920s and 1930s, the University of Cambridge was extremely active in the field of Arctic exploration. Sir James Mann Wordie – Master of St. John's College, co-founder of the Scott Polar Research Institute and a member of Sir Ernest Shackleton's ill-fated Endurance expedition – led five Arctic expeditions between 1923 and 1937 staffed by Cambridge scientists from a wide array of disciplines. These voyages provided training for two archaeologists who were intimately involved with the Museum: Thomas Paterson, who became Director in 1938, and T. C. Lethbridge, honorary Keeper of Anglo-Saxon Antiquities for many years.

At the same time, archaeologists were trying to establish the timeline of human settlement in the Arctic. Expedition members were intent on documenting past and present Inuit life through photography, archaeological excavations and anthropological collecting. MAA holds the collections from these expeditions as well as important finds representing the prehistoric Arctic Dorset Culture, excavated by Graham W. Rowley in the late 1930s.

▶ **Inuit male and female dolls in caribou and sealskin clothes**
Height 22.6 cm and 19.8 cm
Made August 1934
Akudnermiut Inuit; Clyde Inlet, Baffin Island, Nunavut, Canada
Collected on the Wordie Arctic Expedition, 1934. Donated by Thomas T. Paterson
1948.1860 A & B

▼ **Amaunalik, an Inuit woman, teaching Thomas Paterson a string game**
Photograph probably by Montague Ritchie,
12 August 1935
Wordie Expedition base, Thule, Greenland
Paterson Collection N.87628.PAT

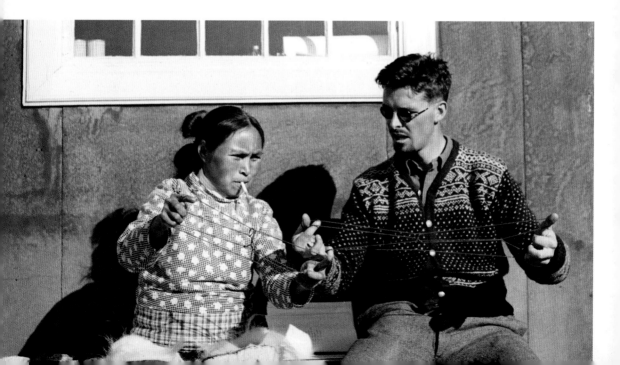

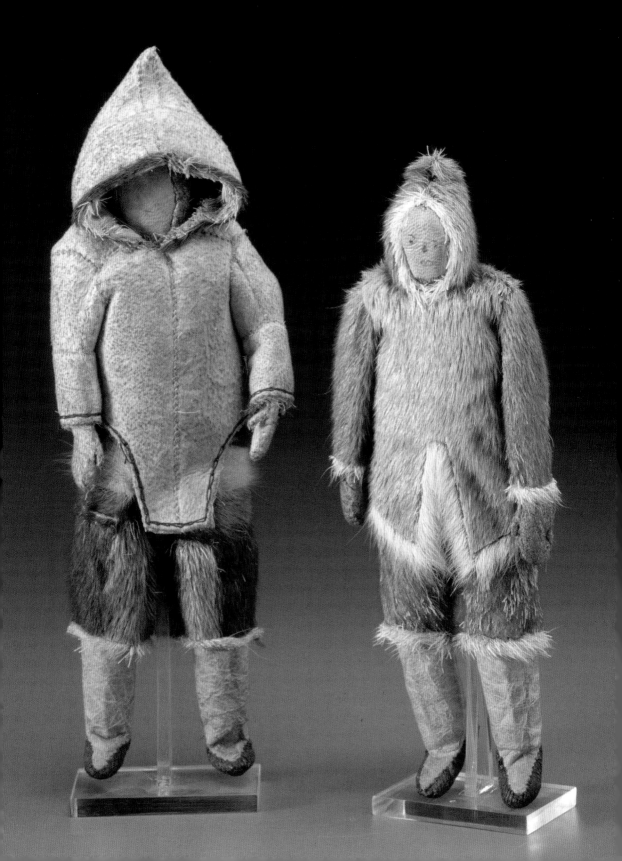

Hunters of the Mesolithic

THE MESOLITHIC SITE of Star Carr in Yorkshire was first systematically excavated by the Cambridge archaeologist Grahame Clark between 1949 and 1951. The site is world famous for the rich variety of material discovered there and for its extraordinarily well-preserved organic materials, which had lain undisturbed in waterlogged ground for over 10,000 years. Wood remains still retained bark; and nearly 200 barbed bone tools were found – constituting the bulk of the entire number known from Mesolithic sites in the UK. The dig remains highly significant, too, in the history of archaeology for its advances in environmental analysis.

Among the most enigmatic and striking artefacts discovered at Star Carr were 21 stag headdresses. They were made from the skulls of red deer, scraped out and with holes bored into the front. Two of these red deer frontlets are held in MAA's collection. No similar object has been found anywhere in Britain, and very few in Europe. What they were used for is unknown. They were probably worn in rituals by the hunters and gatherers who lived at the site, though some scholars have speculated they may have been worn (as part of a disguise, with a deer-skin costume) by hunters when tracking deer. This activity of adopting the behaviour of, or 'becoming' the deer, would have helped the men become better hunters, and hints at a blurring of the boundaries between the animal and human worlds.

▶ **Red deer frontlet**
Height 32 cm
Mesolithic (about 9000 BC)
Star Carr, Seamer,
North Yorkshire
Excavated by Grahame Clark
1953.61 A

▶ **Students excavating
a trench**
1949–51
Lantern slide. Star Carr,
Seamer, North Yorkshire
LS.39287.STARC

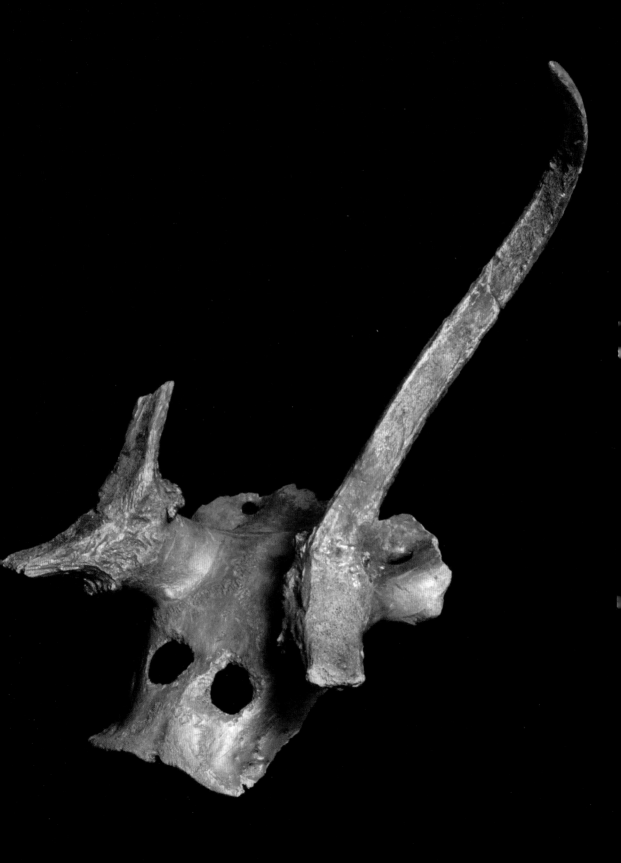

Flint daggers

BEAUTIFULLY FLAKED FLINT daggers first appeared in Denmark in the late Neolithic period and continued to be produced during the early Bronze Age, from around 2300 to 1600 BC. It has long been thought that these daggers, made of very high quality stone, were inspired by the copper variations that were being made in western Europe at the same time.

The flint dagger illustrated here has been carefully and precisely flaked on the hilt in imitation of stitched leather. The 'stitches' extend around the edges of the handle, and in a line down the middle. Recent attempts to replicate these daggers have led to the understanding that metal tools, which began to be imported into Denmark around 2000 BC, were probably used to create the 'stitched' details. Were a dagger of this kind to be used, the handle would need to be wrapped or bound. If this was done, the intricate 'stitching' would be obscured. Hence, it is likely that this object was an expression of prestige of the status of the bearer rather than an actual weapon.

The flint daggers came to the Museum as part of the Walter K. Foster Bequest of 1891. Foster was a patron of archaeological research and a collector; his donation consisted of nearly 3,500 objects from all over the world, and from all periods.

Flint dagger with handle imitating stitched leather
Length 20.5 cm
Bronze Age (1700–500 BC)
Denmark

Foster bequest *Z 39447*

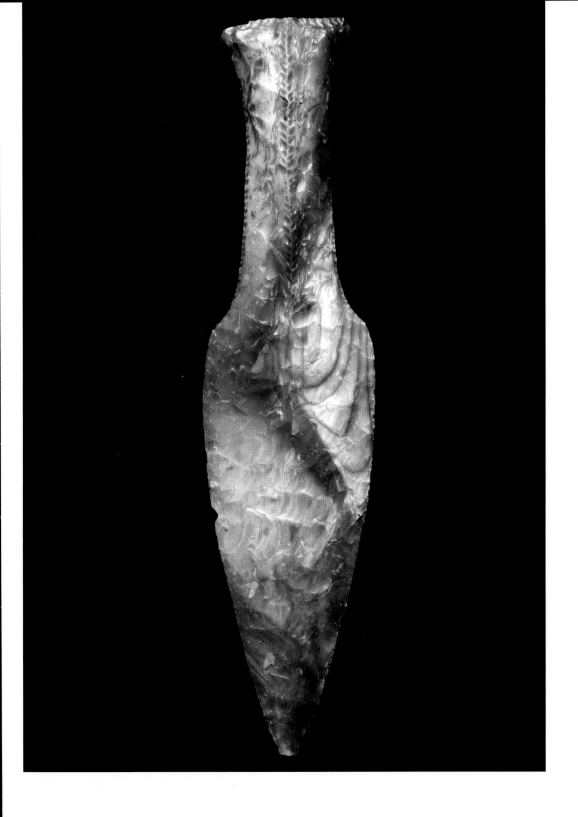

Discoveries from the Swiss lakes

CHARLES LYELL'S *Geological Evidences for the Antiquity of Man* (1863) included a frontispiece featuring newly explored lake dwellings in Switzerland. In his book, Lyell, considered the pre-eminent geologist of his day, had made a somewhat grudging acknowledgement of Charles Darwin's *Origin of Species*, published just four years earlier. Perhaps because this study of human antiquity referred extensively to the Swiss sites, Lyell was soon afterwards sent a collection of material from two well-known sites, Robenhausen and Moosseedorf, by his colleague and friend Adolf von Morlot. The collection was given, probably on Lyell's death, to his good friend and fellow Scotsman Thomas McKenny Hughes, the Woodwardian Professor of Geology in Cambridge. They were transferred to MAA in the 1950s.

The dwellings, dated to 4000–3000 BC, had been uncovered as water levels in some of the Swiss lakes fell over the first half of the nineteenth century. Having been protected by the water, the sites were exceptionally well preserved. The material given to Lyell had been excavated by Morlot and Ferdinand Keller in the 1860s. Though the Neolithic of Europe was by this time

▶ **Greenstone axes in antler handles**
Height 15 cm
Neolithic (about 4000–3000 BC)
Robenhausen, Lake Pfäffikon, and Neuchâtel, Switzerland
Ex Bonney and Ransom Collections 1924.671

▼ **Samples of charred food**
Phials approx. 9.4 cm high
Neolithic (about 4000–3000 BC)
Auvernier and Robenhausen, Switzerland

Collected by Professor T. McKenny Hughes and ex Pell Collection. Transferred from the Sedgwick Museum and purchased by Walter K. Foster
1951.445 A & C, Z 24511

well known, finds of pots, bones and stones had led to it being seen as a rather primitive, early agricultural period. With the discovery of the Swiss lake dwellings, and of similar sites in Italy, Scotland and Ireland, the full richness and sophistication of these societies came to light. These discoveries, and the resulting focus of archaeology on well-preserved wet sites, transformed understanding of later prehistory in Europe.

Early Celtic art

SOME WONDERFUL INDIVIDUAL OBJECTS survive from the last centuries before the conquest of 43 AD brought England into the Roman and Classical world. The fire dog (to hold logs within a hearth) from the hamlet of Lord's Bridge outside Cambridge – later to become famous for the pioneering discoveries of the University radio telescopes there – are the most wonderful example of the ironsmith's art. These exquisite representations of a bull's head and horns are not naturalistic or realistic in their geometry or proportions, and yet they are full of spirit.

They are great examples of 'Early Celtic art' from the Cambridge Antiquarian Society collections, that singular and inspiring art tradition peripheral to or preceding the Roman world. Archaeologists today dispute the kind of society this art tradition represents – how it does or does not relate to the Celtic languages that became modern Breton, Welsh, Scottish and Irish Gaelic. But in its recognisable style, it is distinctive and impressive.

From that same tradition are these enamel plates, part of a hoard from rural Suffolk of varied metal objects. Just as the fire dog is a masterpiece of the smith's art, so these little decorative plates reveal in their enamel work a superb craft knowledge of the technical skill of high-temperature work and applied chemistry.

▶ **Bull's head terminal of a fire dog (detail)**
Height 72 cm
Late Iron Age (100 BC–43 AD)
Lord's Bridge, Barton, Cambridgeshire

Excavated in 1817. Donated by the Cambridge Antiquarian Society
1883.766

▼ **Harness plates**
Height 8 cm and 7 cm
Late Iron Age (100 BC–43 AD)
Santon, Suffolk

Donated by the Cambridge Antiquarian Society
1897.225 A & B

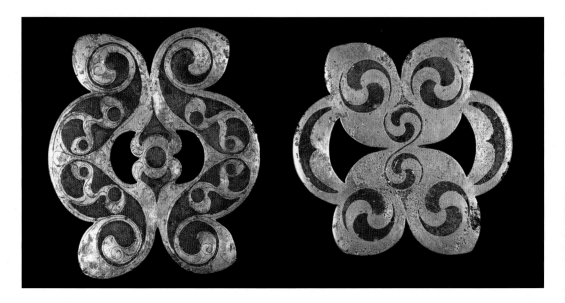

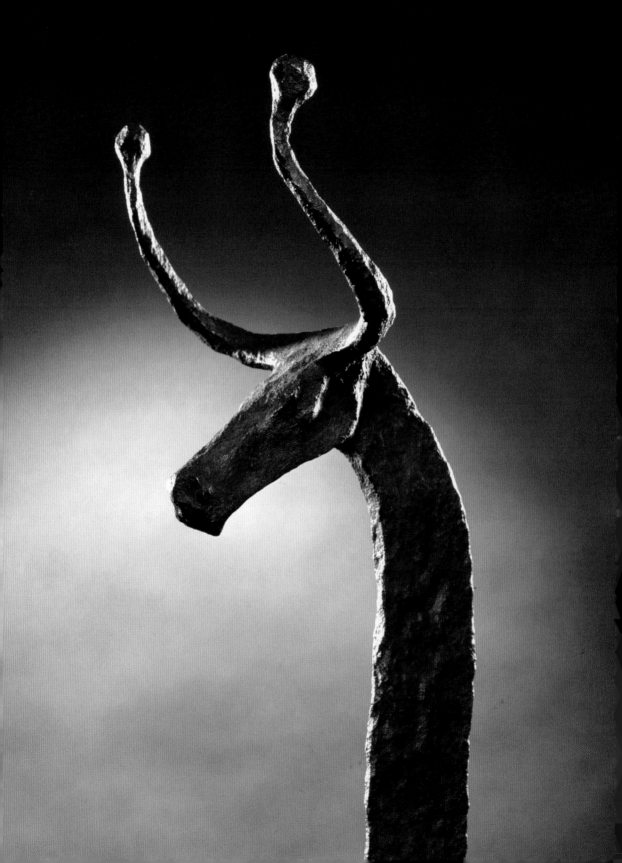

A rude Roman pot

AT FIRST GLANCE, this large and handsome pot, carefully coated with a slip to give it colour, carries a moulded design showing a chariot race. And so it does, but it is notable because the scene is entirely composed using sexual images – mostly male genitals: the chariots, driven by naked women, are pulled by penises instead of horses; a couple make love; other penises are dotted around the scene. In our modern view, it is the visual equivalent of a dirty joke. But to the ancient Greeks and Romans, pictures referring to sex were in decent taste.

The pot probably comes from Great Chesterford, a major Roman town south of Cambridge on the Essex-Cambridgeshire border, from where hundreds of the Roman ceramics in the Museum's collections were excavated. It would have been made with a plain surface, with the decoration piped onto it, rather like icing onto a cake (this is known as 'barbotine'). These kinds of colour-coated wares with their raised decoration are known to come from the Colchester area and from pottery kilns in the Nene Valley near Peterborough, both not far from Great Chesterford. And it was in the Roman city of Colchester in 2004 that archaeologists unearthed the first circus found in Britain, the big open-air arena where chariots were raced.

▶ **Colchesterware beaker depicting a chariot race**
Height 19.9 cm
Roman (43–410 AD)
Great Chesterford, Essex
Z 30141

▼ **Samian ware bowl**
Diameter 20 cm
Roman (43–410 AD)
Great Chesterford, Essex

Excavated by Hughes-Jenkinson. Donated by the Cambridge Antiquarian Society 1883.413

Roman Arbury

IN THE 1950S AND 1960S, new housing estates were being built in Arbury, a northern suburb of Cambridge's city centre. On 19 August 1952, a trenching machine working on Fortescue Road struck the lid of a large stone coffin which contained a male skeleton. An excavation was subsequently undertaken involving local builders, members of the Museum staff and archaeological volunteers. The remains of six further burials, two in lead-lined, stone coffins, and a small building were unearthed, thought to date from the fourth century AD.

Burial 4, in a Barnack stone coffin with a lead lining, was of a woman between 40 and 55 years old. She had been buried in a woollen shroud. Also in the coffin were some snail shells and the skeletons of a shrew and a mouse. Her anklebone had been gnawed by a mouse, presumably the same one found in the coffin.

The coffins were on display in the Museum from the 1950s to the 1980s. Sylvia Plath studied in Cambridge from 1955 to 1957, and evidently visited the gallery, which inspired her poem 'All the Dead Dears'.

▶ **Excavating a Roman coffin**
Arbury Road, Cambridge, 1952
Museum of Archaeology and Anthropology *N.85118*

▼ **Remains of a mouse and a shrew**
Skull 1.9 cm long
Roman (300–400 AD)
Arbury Road Estate, Cambridge, 1952
Excavated by the Museum of Archaeology and Anthropology, 1952. Donated by the Cambridge City Engineer *1952.445 C*

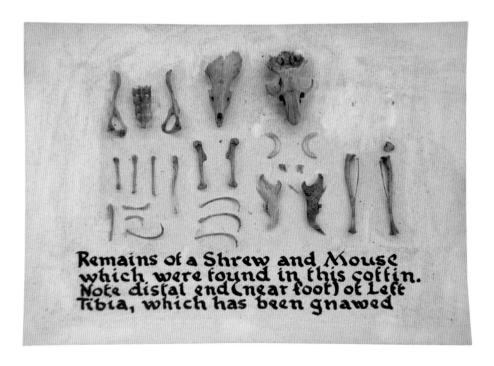

Remains of a Shrew and Mouse which were found in this coffin. Note distal end (near foot) of Left Tibia, which has been gnawed

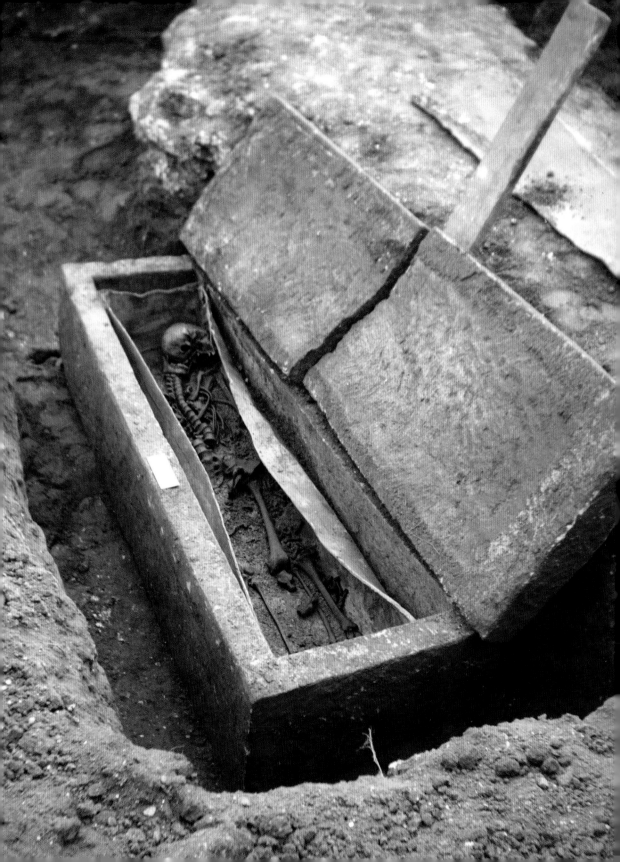

Anglo-Saxon East Anglia

THE ANGLO-SAXON PERIOD stretched from the end of Roman rule in England in the fifth century BC to the Norman Conquest in 1066. The city of Cambridge and its surrounds contain several Anglo-Saxon sites that have been excavated since the foundation of MAA. St. John's College cricket field and Girton College lie on what were once Anglo-Saxon cemeteries. Discovered at these burial sites were cremation urns, jewellery and other personal items which now, along with material from other Anglo-Saxon sites across East Anglia, form part of the Museum's collection.

▶ **Glass trail beaker**
Height 18.5 cm
Anglo-Saxon (600–700 AD)
Dry Drayton, Cambridgeshire

Purchased with a grant from the National Art Collections Fund and Wyman-Abbot Fund *1977.831*

This delicate glass vessel was found in June 1977 during roadworks on the A14, near Dry Drayton in Cambridgeshire. It was made and used by the Anglo-Saxons in the seventh century as a drinking beaker. Since the beaker's base is rounded, it could not have stood on a table so must have been used in conjunction with some sort of stand, or simply passed around. Glass vessels in a wide array of shapes are found in Anglo-Saxon graves across Britain. Most were imported from northern Gaul or the Rhineland, though in the latter part of the period many, including this one, were made in Britain.

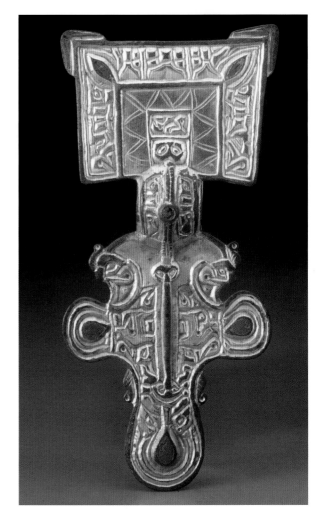

▶ **Square-headed brooch**
Length 18 cm
Anglo-Saxon (550–700 AD)
Linton Heath barrow,
Linton, Cambridgeshire

Excavated 1853
Braybrooke Collection 1948.1553

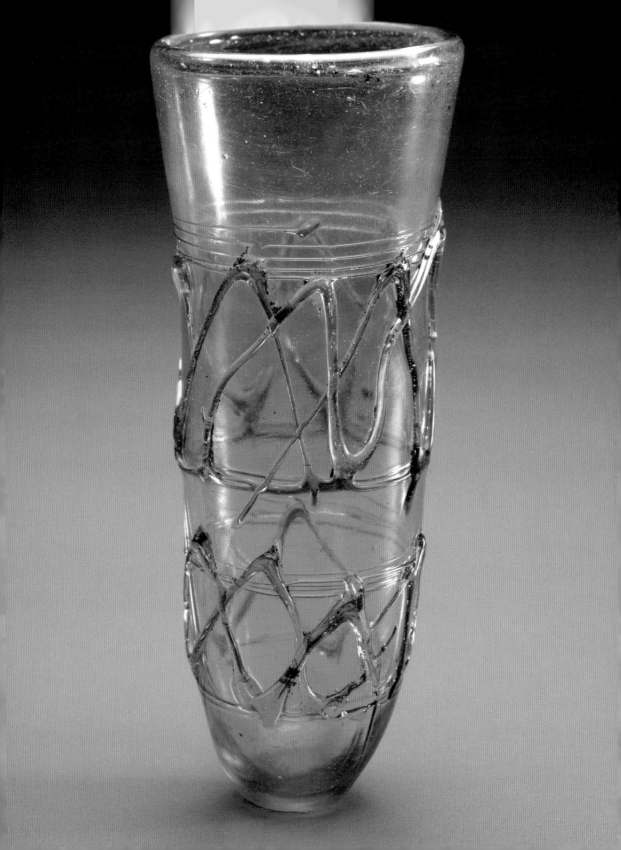

Sacred objects from northern Europe

THE SÁMI ARE AN INDIGENOUS people of northern Europe. Sápmi, their traditional territory, extends across parts of Norway, Sweden, Finland and the Kola Peninsula in Russia.

Ceremonial drums are among the most prestigious of Sámi objects. They enabled shamans to enter a trance-like state, undertake spiritual journeys and communicate with gods and spiritual beings. Christian missions entered the region during the seventeenth and eighteenth centuries, and most drums were subsequently burnt or destroyed. Less than eighty survive now, dispersed among European museums. The absence of Christian symbols suggests that the extremely well-preserved example below, owned by Trinity College, predates missionary expansion into Sápmi.

Since the 1970s, Sámi have sought the repatriation of their drums and other sacred objects. In 1998, the Lule drum shown here was loaned to the Ájtte Museum in Jokkmokk, where it became the centrepiece of a new exhibition that introduced younger generations to the Sámi cosmology of the pre-Christian era. The drum remained at this local museum for ten years until its return to Cambridge in 2008, and is now celebrated in a new display created with Sámi advice and support.

In 2007, the Museum commissioned the Sámi artist Helge Sunna to make a contemporary drum for the Cambridge collection. Sunna began making copies of historic drums in the 1960s, but by the 1990s had moved on to introduce new materials, images and elements of contemporary Sámi life. The new drums are not sacred; they combine contemporary art and traditional handicraft to offer a vibrant perspective on Sámi peoples, past and present.

▶ **Drum**
Height 58 cm
Made by Helge Sunna
Rotebro, Sápmi, Sweden
Commissioned for MAA by
Carine Durand 2008.118

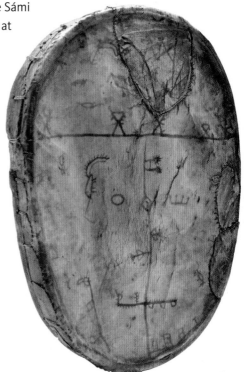

▶ **Ceremonial Drum**
Height 40 cm
18th century
Lule Sámi area, Sápmi, Sweden
Deposited by the Master and
Fellows of Trinity College
D 1914.88

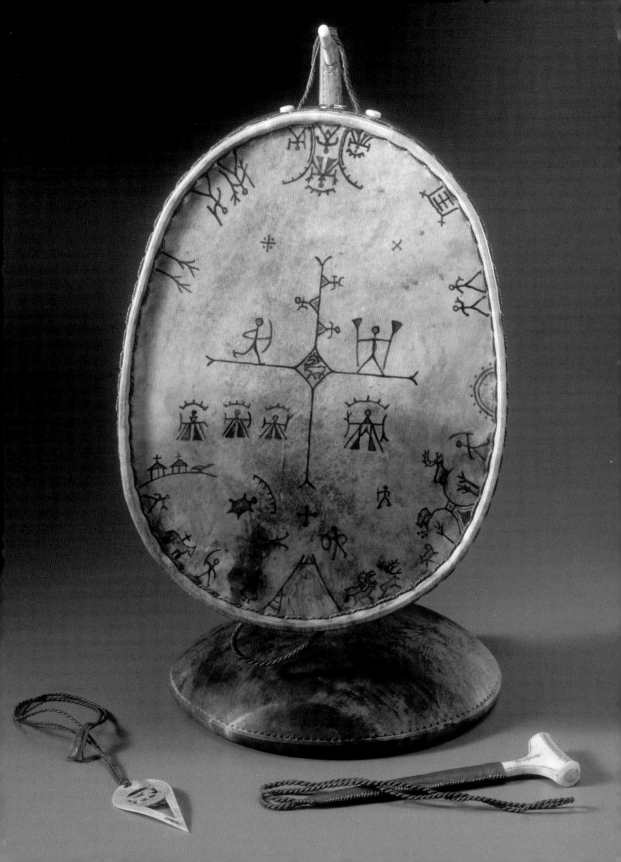

Allen, Harry (ed.), *Australia: William Blandowski's illustrated encyclopaedia of Aboriginal Australia*. Canberra: Aboriginal Studies Press, 2010.

Boast, Robin, Sudeshna Guha and Anita Herle, *Collected sights: photographic collections of the Museum of Archaeology and Anthropology*. Cambridge: Museum of Archaeology and Anthropology, 2001.

Coombes, A. E. S., *Re-inventing Africa: museums, material culture and popular imagination*. London: Yale University Press, 1994.

Ebin, V. and D. A. Swallow, '*The proper study of mankind' – great anthropological collections in Cambridge*. Cambridge: Museum of Archaeology and Anthropology, 1984.

Fürer-Haimendorf, Christoph von, *The naked Nagas*. Calcutta: Thacker, Spink & Co., 1946.

Gadow, Hans, *Through southern Mexico*. London: Witherby, 1908.

Graham, Ian, *Alfred Maudslay and the Maya*. London: British Museum, 2002.

Herle, Anita and Sandra Rouse (eds.), *Cambridge and the Torres Strait*. Cambridge: Cambridge University Press, 1998.

Herle, Anita and Andrew Moutu, *Paired brothers: concealment and revelation*. Cambridge: Museum of Archaeology and Anthropology, 2004.

Herle, Anita, Mark Elliott and Rebecca Empson (eds.), *Assembling bodies: art, science and imagination*. Cambridge: Museum of Archaeology and Anthropology, 2009.

Jones, G. I., *The art of eastern Nigeria*. Cambridge: Cambridge University Press, 1984.

McKitterick, David, 'From Camden to Cambridge: Sir Robert Cotton's Roman inscriptions, and their subsequent treatment', in C. J. Wright (ed.), *Sir Robert Cotton as collector: essays on an Early Stuart courtier and his legacy*, pp. 105-28. London/Toronto: British Library/University of Toronto Press, 1997.

Phillipson, David, *Ancient churches of Ethiopia*. London: Yale University Press, 2009.

Raymond, Rosanna and Amiria Salmond (eds.), *Pasifika styles: artists inside the museum*. Dunedin: University of Otago Press, 2008.

Roscoe, John, *The Baganda*. London: Macmillan, 1911.

Roth, Jane and Steven Hooper (eds.), *The Fiji journals of Baron Anatole von Hügel*. Suva/Cambridge: Fiji Museum/ Museum of Archaeology and Anthropology, 1990.

Smith, Pamela Jane, *A 'splendid idiosyncrasy': prehistory at Cambridge, 1915–50*. Oxford: BAR, 2009.

Thomas, Nicholas, *Entangled objects: exchange, material culture and colonialism in the pacific*. Cambridge, Mass.: Harvard University Press, 1991.

Thompson, M. W., *The Cambridge Antiquarian Society 1840–1990*. Cambridge: CAS, 1990.